GET LOST!

the cool guide to
San Francisco

Claudia Lehan | Get Lost Publishing | 2006

British Library in Publication Data. A catalogue record for this book is available from the British Library.

ISBN: 90-76499-04-7

Thank you!!
Ben, Bing, Chris, Chris & Mikki, Cushman, Darlene, Dennis, Ernesto, Jeff, Jess, Jim, Kate, Larry, Margie, Marina, Mona, Monica, Robert, Roberto, Shelley, Steve, Tano, Trenton. And special thanks to Joe & Lisa for all their guidance and moral support.

Editing **Lisa Kristensen & Joe Pauker**
Additional research and text **Dennis Conroy**
Cover design and book layout **Ellen Pauker**
Photos . **Claudia Lehan**

Introduction

Welcome to the new and improved, 3rd edition of *Get Lost! The Cool Guide to San Francisco*. I've revamped the format and sorted much of the information by district this time. I've also added a Day Trips section.

Get Lost! is an independent, DIY project. We've sold a few ads to help cover the cost of printing, but nobody pays to be included in any of *The Cool Guides*.

As always, no trees were harmed in the making of this book. The inside pages are printed on 100% post-consumer recycled paper with vegetable-based inks.

I've done my best to be as accurate as possible with all the information in this book but hey, things change, and I'm only human. I'm confident that most of you out there can deal with it, but feel free to write if you have any suggestions, complaints, random thoughts or lots of cash. You can contact me via the addresses below.

Thanks for buying this edition of *The Cool Guide to San Francisco*. I hope you have as much fun using it as I had doing the research and writing it.

GET LOST!
Box 18521
1001 WB Amsterdam
The Netherlands

www.xs4all.nl/~getlost

Contents

contents

contents

About The Author

Claudia Lehan was born in a small town in Western Massachusetts. Suffering from a mean case of the travel bug, she left the Happy Valley to explore the world. She traveled extensively, lived as a squatter in Amsterdam, and toured with a punk rock band throughout Europe. Currently, Claudia lives in San Francisco where she works in the film industry, plays with various musical projects, and struggles to write short biographies about herself.

Places To Sleep

There are lots of cheap places to sleep in San Francisco and many options in terms of neighborhood and degree of privacy. The prices quoted here do not include "hotel tax", which is 14%. Also, prices tend to go up some from May to October. In general, hostels have dormitory sleeping quarters, shared bathrooms and kitchens, and beds from $12 to $30. Some **hostels** also offer private or shared rooms. The lower-priced **hotels** usually cost from $30 to $50 for a single, and $60 to $80 for a double off-season, and $5 to $10 more during peak season. Wherever possible I've quoted both the high- and low-season rates.

A good place to start your search for a bed is the **Visitor Information Center** (*www.sfvisitor.org*; mon-fri 9-5; sat/sun & holidays 9-3; tel: 415-391-2000). The V.I.C. is located in Hallidie Plaza, at 900 Market Street, next to the Powell Street BART station and the cable car turnaround. All of the underground metro lines and the Market Street buses stop here. They've got flyers and a rack full of discount coupons for hotels. Note that they're closed Sundays from November through April, Christmas Day, New Year's Day, Thanksgiving, and Easter.

If you're planning to stay in SF for a while, your best bet is to try to find a temporary **sublet** in a shared house. However, rents here are among the highest in the US and if you can find a room for under $500 a month, you'll be very lucky. The best and easiest place to start looking for a sublet is *www.craigslist.org*. Another place to check is the info table and bulletin board at the main entrance to Rainbow Groceries (1745 Folsom Street; Bus 12 - look for the big highway underpass; see Food chapter).

When you're deciding where to stay, keep in mind that, like any big city, San Francisco has some rough neighborhoods. The Tenderloin, for instance, has some great bars and restaurants, but there's nothing tender about it. You should keep your wits about you there, especially if you're heading back to your hotel after a late night out. Just be aware. 'Nuff said.

For some additional places to sleep, out of town but nearby, see the Day Trips and Overnight Jaunts section of the Getting Out of SF chapter.

hostels

Elements Hostel Rooftop

Elements Hostel - 2524 Mission St (btwn 21st & 22nd), 647-4100 or 1-866-327-8407

www.elementshotel.com

This recently opened hostel is in a really amazing location: right in the middle of the Mission district, surrounded by some of the best restaurants, bars, and live music venues in the city. It's an easy walk to other parts of the city and the 24th Street BART station is only a couple of blocks away. The rooms are clean and comfortable, and both dormitory-style and private rooms are available - each with their own bathroom. **Free internet** service,

free breakfast, cheap washing machines, movie nights, and rooftop barbeque parties, ensure that you'll have a memorable stay. But the clincher for me is the roof deck, with a bar, grill, and heat lamps. There's a good view up there and from the right vantage point, you can see the films projected on the wall next door at Foreign Cinema (see Mission chapter, Food section). Beds in the dorm rooms (for 4 to 12 people) are $25 per night; in private rooms with two bunks, $29; and a private double with one bed is $29.99. Prices go up in July and August. (Mission)

Hostelling International (HI) SF Downtown
312 Mason St (btwn Geary & O'Farrell), 788-5604

www.sfhostels.com

This hostel, within walking distance of Union Square, is also conveniently close to public transportation. It's open to non-Bay-Area residents only, and costs just $22 for a shared room if you're an HI member (and a few bucks more if you're not). The rooms have four or five bunk beds each, and there are an adequate number of bathrooms. Sleeping quarters at the HI hostels are separated by gender unless you rent a private room. Smoking is only allowed in the smoking room, which has comfy couches, and is where a lot of the social action happens. There's also a TV room where they show free movies, a library with a book exchange, a good-sized kitchen with all the amenities, and **internet with wifi access**. The friendly staff members are chock-full of information about where to go, what to do, and how to do it cheap or free. Reservations are highly recommended. The HI SF Downtown is located about 2 blocks from the Powell Street BART Station. (Tenderloin)

Hostelling International (HI) City Center - 685 Ellis St (at Larkin), 474-5721
www.sfhostels.com

This is the newest of the HI hostels in the city and it's a bit more luxurious than the others. Each room has a private bath attached - and that's a big plus. It's also very close to all sorts of public transportation, making it an easy jumping-off point for exploring many neighborhoods. The kitchen is fully equipped and there's **free wifi and internet access**. Beds cost from $22 to $29. (Tenderloin)

Hostelling International (HI) Fisherman's Wharf
Fort Mason, Building 240, 771-7277

www.sfhostels.com

If you want a break from the urban scene, but want to stay near the city, this could be the hostel for you. It's located between Fisherman's Wharf and the Marina, above Fort Mason. There's a gorgeous view from here of the whole Bay, including the Golden Gate Bridge and Alcatraz. $22.50 to $29 per night gets you a dorm bed and a free breakfast in their café. The big, cozy fireplace looks like it would be lovely on a foggy evening. Another amazing feature of this place is that there's **free parking**, which, believe me, is a rare thing in SF. If you're bussing, take MUNI bus 10, 30 or 49. (Marina)

Adelaide Hostel
5 Isadora Duncan Lane (btwn Post & Geary; Jones & Taylor), 359-1915 or 1-877-359-1915 (toll free)
www.adelaidehostel.com

I keep hearing good things about this clean, friendly hostel. It's a small place, within easy walking distance of Chinatown and North Beach as well as Union Square and public transportation. The dorm rooms, with a maximum of 4 bunk beds in each, are $20 per person; private single and double rooms have TVs and start at $55. All bathrooms are shared. The street they're located on used to be called Adelaide Street, so if you have an older map, look out for that.

Green Tortoise Guest House
494 Broadway (btwn Kearny & Montgomery), 1-800-867-8647 or 834-1000

www.greentortoise.com

This is a very laid-back place in a great location - right in the middle of North Beach. You can bring in your own beer and there's a cool old ball-roomlike space to party in: a friendly place to hang if you're traveling alone. There's a very spacious, fully-equipped kitchen, and three nights a week you're offered **free dinner**. That's a good deal! **Bed linen and high-speed internet are free as well**. There are 130 beds in all, and a limited number of toilets on each floor, which may make for a little bit of waiting. But, in my book, they get major bonus points for the sauna (clothing optional). This hostel is often full in the summer, but if you're traveling with one of their bus tours (see Getting Out of SF) you're guaranteed a room. Dorm beds start at $20 per night and private rooms (from $52) are also available. If you have a picture ID and a passport you can stay for up to 21 days. Take bus 30. (North Beach)

American Youth Hostel (AYH) Marin Headlands
941 Fort Barry (Sausalito), 331-2777

www.norcalhostels.org

Located just four miles from the Golden Gate Bridge in the Marin Headlands, this place is a great get-away from the city. The hostel is in a beautifully restored old building that sits in the middle of an idyllic setting very close to the ocean. It's a great base for day hikes to Mount Tam and Muir Woods (see Getting Out of SF chapter). On weekends you can take MUNI bus 76 which will drop you at the nearby Marin Headlands Visitors' Center. Alternately, it's a fairly easy bicycle ride from the Golden Gate Bridge. The hostel is open 24 hours. Check-in is at 3:30pm and check out is at 11am. Dorm beds cost $18, and private rooms start at $54. (Sausalito)

hotels

Aida Hotel - 1087 Market St (btwn 6th & 7th), 863-4141 or 1-800-863-AIDA

I love the old-fashioned elevator and the funky, forties-style lobby of this hotel. Single rooms with a shared bath go for $45, or $60 with private bath. Double rooms with shared bath are $65; $75 with private bath. The bedrooms and bathrooms look very clean and a complimentary breakfast is served in a nice, big dining room. Ask for a room at the top for more light and a view. Civic Center is the closest MUNI /BART station. (Civic Center)

Hotel Astoria - 510 Bush St (at Grant), 434-8889

www.hotelastoria-sf.com

This hotel is in a great location, right next to the famous Chinatown Gate. Prices range from $40 to $80 and additional people can be squeezed into rooms for a small surcharge. From the Powell Street MUNI/BART station, follow the cable car tracks 5 blocks to Bush Street; then walk one block east. (Downtown)

Edwardian Hotel - 1668 Market St (btwn Gough & Franklin), 864-1271 or 1-888-864-8070

www.edwardiansfhotel.com

This recently remodeled hotel may be a bit of a splurge if you're traveling on a budget, but it's in a convenient locale and it's very comfortable. Single rooms with shared bath cost from $59 to $99 (depending on the season). Single rooms with private baths are $95 to $109. Coffee and tea are free all day and there's a nice-looking wine bar next door. Note that Market

is a busy street, so you might want to ask for a room in the back where it's quieter. The closest cross street is Van Ness. (Fillmore)

Twin Peaks - 2160 Market Street (where Sanchez meets 15th), 863-2909

This place is close to the Castro district and, consequently, you may have trouble getting a reservation during Gay Pride Weekend (see Hanging Out chapter) or the Folsom Street Fair (see South of Market chapter), but at other times it's not as busy. The area is safe and easy to reach by public transportation. A room with a private bath costs $55. A single room with a shared bath goes for $45. The shared bathrooms are split (with the toilet in one room and the shower in the other), which makes for less waiting. Ask for one of the quieter rooms at the back. Take the K, L or M MUNI Metro to Church Street. (Fillmore)

bed & breakfasts

San Francisco is jam-packed with Bed-and-Breakfast places. The prices are comparable to many hotels and staying in one can be a great way to get to know a neighborhood, as opposed to some sterile downtown hotel block - plus you're guaranteed a decent breakfast. Check *www.bbsf.com* for Bed & Breakfast accommodations in the city, as well as in the surrounding Bay Area. You can make reservations online or by calling 1-800-452-8249.

The Country Cottage - 5 Dolores Terrace (off Dolores, btwn 17th & 18th), 899-0060
www.bbhost.com/countrycottage

Personally, I recommend this clean and friendly B & B. If you're staying in San Francisco for a while it's a pleasant place to put up all the family members who'll want to come and visit you. Prices range from $70 to $80.

hotel strips

Since San Francisco is one of the most visited cities in the world, there are a lot of reasonably priced hotels around. However, walking around and looking for one can be a pain, so here are a few areas with clusters of hotels, which should make it a little easier for you.

Union Square

This area is near the Visitors' Information Center, and right in the heart of downtown. There are a lot of hotels on the streets just off the Square, in all different price ranges. Post and Geary are good streets to check out. Also Stockton and Grant, just before you get into Chinatown.

Lombard Street

This is a nice neighborhood with a beach-like feel because it's right by the Bay and the Marina. From Van Ness to the Exploratorium there are a whole lot of hotels and motels.

South of Market

There are much more pleasant areas to stay in, but if you're desperate, there are a number of hotels between Market and Folsom, from about 5th Street to 9th Street. Some of them are pretty scummy looking, so be sure to see the room before you pay.

Getting Around

The Visitors' Information Center (see Places to Sleep chapter) provides free maps of the city that are actually pretty decent. But if you're planning to use public transport during your stay, do yourself a favor and invest in the official *MUNI Street and Transit Map*, which includes all the routes on all the systems. They're sold at bookstores and corner stores all over town and cost $4.

public transport

For information about every form of public transportation in the Bay Area, visit this extremely detailed website: *www.transitinfo.org*. A handy website for planning an itinerary is: *www.511.org* (click on the "take transit trip planner" link).

MUNI (Municipal Railway)

www.sfmuni.com

This fairly extensive bus and rail system is also one of the oldest publicly owned transit systems in the US. A ride costs $1.50 and exact change is required. You can use a dollar bill when boarding an above-ground MUNI bus, but when underground, the turnstiles will only accept coins (you can get change from the wall-mounted BART kiosks in every station). Make sure you get a transfer: they're valid for 2 more rides or 2 more hours, whichever comes first. Most buses stop running at around 1:00 in the morning, but there are some lines that run until 5:00. Buses on this "Owl Service" schedule run about every 30 minutes. If you're confused about how to get where you're going, call the hotline: 673 MUNI.

BART (Bay Area Rapid Transit)

www.bart.gov

This rail system runs further afield than the MUNI - through the city to Oakland, Berkeley and other points in the East Bay. Hours of operation are: 4am to midnight on weekdays; 6am to midnight on Saturdays; and 8am to midnight on Sundays and holidays. Fares start at $1.25 and are based on how far you travel. Tickets are available from the wall-mounted kiosks found in every station. The machines accept bills, change, and debit/credit cards. At most stations you'll find brochures listing the schedules of all the BART trains. The schedules are also available online, or you can call 989-2278 for info.

Cable Cars

You're supposed to pay $5 every time you hop on one of these San Francisco icons. You don't need to have exact change, but the conductor can't accept anything bigger than a twenty. If your stop comes before the conductor reaches your part of the car, however, you might just get lucky and catch a free ride for a short distance. By the way, you don't have to wait in the long line that forms at Powell and Market, where the cable cars turn around. Just walk up a block or two and wait by one of the brown-and-white signs. Hanging off the sides and singing about Rice-a-Roni is always fun. This experience can be heightened with alcohol. Hold on tight!

Passes

Buying a "Fast Pass" is a good idea if you plan to be here for a while. They cost $45 and give you unlimited access to all MUNI buses and trains, BART, Caltrain, and cable cars for a month. "Passports", valid for 1, 3 and 7 days are also available and cost $11, $18 and $24, respectively. Passes and Passports also entitle you to discounts on some visitor attractions, including the museums in Golden Gate Park (see Museums chapter). For other, similar special-offer packages, check *www.gosanfranciscocard.com*.

bicycles

One look at San Francisco's famous hills scares many visitors off the idea of biking in the city, but it's actually a wonderful place for cyclists. There are many routes that avoid the worst of the hills (see, for example, page 14, for a map of "the wiggle" - one of the best ways to cross town). Also, in order to reach the top of the most daunting slopes, it's possible to take your bike with you on public transit (see below for details). Outside of the city center, throughout the Bay Area, there are also an incredible number of gorgeous rides (see Getting Out of SF chapter). It's not surprising then that bike lovers and cycle-rights activists are so numerous and vocal here. This section will give you all the information you need to know to get yourself some wheels and join the fun.

Well-marked bike lanes, the right to take your wheels with you on public transit: many of the things that make it possible and pleasurable to ride here are the result of the efforts of dedicated activists. Organizations like the SF Bike Coalition (*www.sfbike.org*) and Transportation for a Livable City (*www.livablecity.org*) lobby and work with city officials to continue to make SF more bike- and pedestrian-friendly.

In spite of the bike-positive features of the city, however, riding defensively everywhere and at all times is essential. Congestion in the streets is horrible during rush hour and when people are impatient they tend to drive like assholes. Watch out for the doors of parked cars - drivers routinely throw them open without looking.

You can bring your bike with you onto BART trains, but not during the rush hours (6:30 to 9:00am and 3:30 to 6:30pm). On weekends and holidays there are no time restrictions. You can get on any car on the train except the first one. Call (510) 464-7133 for more info. As for the buses: exterior bike racks are available during all hours of operation on many of those operated by MUNI and Golden Gate Transit. They're easy to use and are the best way to get over some of San Francisco's steepest hills with your bike. Simply slip your front tire into the designated spot and secure it with the metal rack that's provided. For detailed info about specific buses and times, call 673-MUNI.

To hear lots of taped info about riding in the city, bringing your bike with you on mass transit, or to request free maps, call the SF Bicycle Information Hotline at 585-BIKE.

NOTE: don't ever leave your bike unlocked in San Francisco, even if you're just popping into a shop for a second. If you're downtown, the safest place to leave your bike is at the attended bike parking area at the Embarcadero BART/MUNI station where you can leave your bike for free. Drop-off and pick-up times are from 7:30 to 9:30am and 3:00 to 7:00pm.

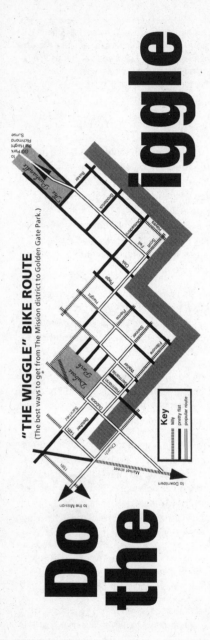

"THE WIGGLE" BIKE ROUTE
(The best ways to get from The Mission district to Golden Gate Park.)

Key
hilly
pretty flat
popular route

to Downtown

to the Mission

Market Street

Sunset
Richmond
the Haight
GG Park
to

The Bike Hut - Pier 40 on the Embarcadero (at Townsend), 543-4335

www.thebikehut.com

This tiny hut is a particularly inexpensive place to rent or buy a bike. And it's a great place to support. It's a non-profit business that teaches bike repair and business skills to kids from low-income communities. They rent bikes for just $5 an hour (or $20 a day) - including a lock and helmet. And check this: if you decide you want to have your own wheels shipped here from home, they'll let you use their address. Also, when you're leaving town, donating a used bike to these folks gets you great karma. Open: daily 10-6 (unless it's raining).

Bike Kitchen - 2955 18th St (btwn Florida & Alabama), 648-7562

www.bikekitchen.org

If you know how to fix your own bike but need some tools, advice, or the company of other bike-minded folks, check out this volunteer-run place. They don't charge for their services, but do ask for a $5 per day membership fee. At the moment, they are located in the Mission Village Market, a flea market at the above address, but unfortunately it's scheduled for demolition. Check the Bike Kitchen website to confirm their address before heading over. Open: tues: 7-9pm; sat 11-4. (Mission District, for now)

Pedal Revolution - 3085 21st St (btwn Folsom & South Van Ness), 641-1264

www.pedalrevolution.com

If you're planning to be here for a while you may want to consider buying a used bike and then selling it when you leave. You can get yourself some refurbished wheels at a fair price at this non-profit bike store in the Mission. Like The Bike Hut (see above) they also provide job training and employment to kids in need and they're a great organization to support. Open: mon-sat 10-6; sun 11-5. (Mission)

Box Dog Bikes - 499 14th St (at Guerrero), 431-9627

www.boxdogbikes.com

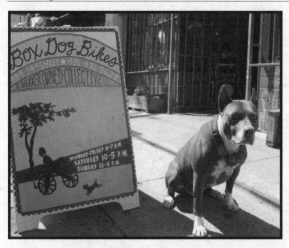

This new, worker-owned collective is located right on the best bike route from the Haight to the Mission. These guys are extremely accommodating and can probably help you with any of your biking needs. They can rent or sell you a used bike or, if you're handy, rent you tools so you can fix up or build your own - lots of spare parts kicking around here. Even the shop mascot, Coco the dog, is friendly and helpful. Open: mon-fri 1-7; sat 10-5; sun 12-5. (Mission)

San Francisco Cyclery

672 Stanyan (btwn Haight & Page, behind Cala Supermarket parking lot), 379-3870

www.sanfranciscocyclery.com

This new bike rental/repair/sales shop is a welcome addition to the neighborhood. It's women-owned and I find it a very comfortable place to bring my bike when it needs a little tender loving care. It's in a great location - right at the top of Golden Gate Park - making it a convenient place to rent a bike and go exploring. Rental costs $20 for up to 4 hours; $30 a day (8 hours); and $100 a week. The price includes a lock and helmet. Open: wed-mon 10-6. (Haight- Ashbury)

Wheel Fun - 50 Stow Lake Drive (at the Stow Lake boathouse), 668-6699

www.wheelfunrentals.com

You can rent bikes or surreys here (those 3- and 4-wheeled contraptions that take a few people to pedal). Wheel Fun is located in a boat house at Stow Lake, in the middle of Golden Gate Park (see Hanging Out chapter), and you can also rent paddle boats. Mountain bikes cost $25 a day or $8 an hour, with a one-hour minimum. A surrey goes for $20 an hour. Open: daily 9am-dusk, weather permitting. (Golden Gate Park)

inline skates

The Midnight Rollers Friday Night Skate is an event not to be missed if you're an inline or roller skater. Strap some wheels on your feet and join the boisterous crowd who come from all over the place for this event. Every Friday night at about 8:30pm they gather in Ferry Plaza, across from the Ferry Building on the Embarcadero at the foot of Market Street. The route is something like 12 miles long, but it's fairly flat, so you don't need to be a seasoned pro to keep up. Check out their website for more details: http://web.cora.org/friday.phtml.

Its wide streets and gentle downhills make Golden Gate Park (see Hanging Out chapter) an ideal place to skate, especially on Sundays when the park is closed to cars until 6:00. The entrance by 6th Avenue at Kennedy Drive is where people meet and do some crazy-ass line dancing to a boom box. It's worth going to look at, even if you're not a skater. Wear your favorite tube top. And if you find yourself inspired and want to rent a pair of skates, head over to Golden Gate Park Skate and Bike (3038 Fulton St, at 6th; 668-1117) - just follow 6th Avenue out of the park and cross Fulton Street. They rent inline skates for $6 an hour or $24 a day. (No deposit is required, but you'll need to leave your license, credit card, or passport.) The shop is open weekdays from 10 to 6:00 and weekends 'til 7:00.

Critical Mass

Since 1992, dedicated cyclists have gathered once a month for a raucous ride through the city, reclaiming the streets for bicycles and pedestrians in what has become a famous event. For more info on the history of the movement and their efforts to promote bike awareness and safety, visit *www.scorcher.org/cmhistory*. To join the Critical Mass cyclists on a ride, go to Justin Herman Plaza (Embarcadero) at about 5:30pm on the last Friday of the month.

cars

It's time San Francisco and other big American cities stopped worshiping at the altar of car culture. There are too many damn cars in the city! If you have to bring a car with you on your visit, try to avoid driving downtown: the one-way streets make navigation really difficult and parking is a royal pain in the ass .

If you **park on the street**, don't do it where the curb is painted yellow, red or white - and watch out for bus stops. Be sure you've got lots of quarters for the hungry meters. If you're parking overnight, look for the signs telling you when they clean the streets because you may have to move your car early in the morning to avoid a ticket. If you're unfortunate enough to have your car **towed**, call the DPT Tow Line for information: 553-1235. It's likely that AutoReturn will have your car and you'll need to go down to their office at 850 Bryant, room 145 in the Hall of Justice (in the South of Market district, between 6th & 7th streets) to pay fees. Call first: 558-7411. It'll cost you about $182 bucks, and after 4 hours storage fees start adding up so get down there right away. If your car wasn't towed and you think it was stolen, call the SF Police Department: 553-0123.

Here are the addresses of a couple of **city-owned parking garages** with reasonable rates - a sensible alternative to cruising around for hours in search of a street space.

Civic Center Plaza Garage - 355 McAllister St (btwn Polk & Larkin), 863-1537.

Open: mon-thurs 6-12; fri 6-1; sat 8-1; sun 8-12.

Ellis-O'Farrell Garage - 123 O'Farrell St (btwn Powell & Stockton), 986-4800.

Convenient to Union Square. Open: sun-thurs 5:30-1; fri/sat 5:30-2.

Yerba Buena Gardens Garage - 833 Mission St (at 5th St), 982-8522.

Takes up almost a whole block in the Mission. Open: always.

Japan Center Garage - 1660 Geary Blvd (btwn Buchanan & Webster), 567-4573.

Open: mon-fri 5-2:30; sat/sun 7-3.

North Beach Garage - 735 Vallejo St (btwn Stockton & Powell), 399-9564.

Open: 24 hours a day.

Portsmouth Square Garage - 733 Kearny St (btwn Washington & Clay), 982-6353.

Right in the middle of Chinatown. Open: 24/7.

car rental

If you'd prefer to avoid the big chains, here are a couple of smaller places that I've found to be reliable and competitively priced...

Rent-a-Wreck - 2955 3rd St (btwn Cesar Chavez & 25th), 282-6293

www.rent-a-wreck.com

These guys are in a slightly out-of-the-way locale, but don't let that scare you off, because they'll come pick you up. Their rates are cheap and everyone who works there is very nice. Open: mon-fri 7am-6pm; sat 8am-1pm. (Mission)

A-One - 434 O'Farrell (btwn Taylor & Jones), 771-3977

www.aonerents.com

If you're 21 to 25 years old take note: this place won't slap on a surcharge just because you're young (most places do). And if you have a foreign passport, they'll rent to you even if you don't have a credit card (most places won't). They have large vans (15-seaters) that are great for road trips and the price isn't bad once you split it up amongst your crowd. Open: mon-fri 8-6; sat 8-5. (Tenderloin)

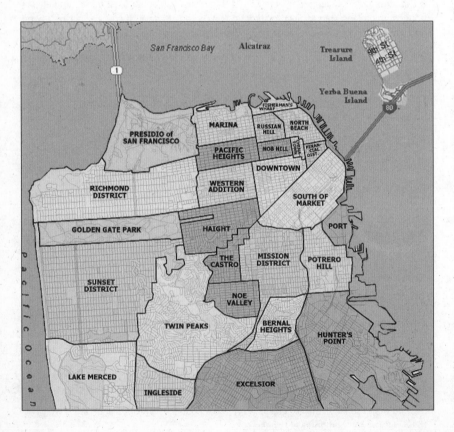

Getting Out of San Francisco

ferries

The Blue & Gold Fleet ferries (*www.blueandgoldfleet.com*) leave from Pier 41 at Fisherman's Wharf and go to Sausalito, Tiburon, Alcatraz (see Museums chapter), and Angel Island (see Getting Out of SF chapter). Bicycles are allowed on all the ferries at no extra charge. Blue & Gold also offers trips to Sonoma-Napa wine country, Monterey-Carmel, and Muir Woods. Check their website for detailed information. I strongly recommend buying advanced tickets in the summer, in spite of the $2.25 per ticket booking fee. The ferries to Alcatraz, in particular, are often very full. Call 705-5555 or swing by their box office on Pier 41. Open: tue/wed 8:30am-6pm; thurs-mon 8:30am-7pm. (Fisherman's Wharf)

buses

The cheapest way to get across the country is via Greyhound (see below), but if you want to see some sights on your way, there are a couple of bus adventure companies that offer very cheap tours for budget travelers. They often stop at amazing, out-of-the-way places that you might never get to see otherwise. They usually charge a small amount for food, and everyone pitches in to cook and clean up. It's a fun way to go, especially if you're traveling alone, as you're bound to meet a lot of interesting people.

Green Tortoise - 494 Broadway (btwn Montgomery & Kearny), 956-7500 or 1-800 -TORTOISE
www.greentortoise.com

This company is highly recommended by cool people everywhere. They've been around since 1974 and they're probably the most famous adventure tour group. Their converted buses are comfortable - you'll get a good night's sleep and then wake up somewhere beautiful. Everyone is expected to help with cooking and cleaning up, and you pay a nominal fee for excellent, mostly vegetarian, meals. They're known for stopping at hot springs and mud baths, and they can recommend places to go white water rafting or scuba diving. It's a great way to go cross-country, down to Central America, or to closer destinations like Yosemite, Death Valley and Las Vegas. Buses arrive and depart from behind the Transbay Terminal at the corner of 1st and Natoma Streets. Stop in at the Green Tortoise Guest House (see Places to Sleep chapter) and pick up a schedule, or check out their detailed website. But whatever your source of info, be sure to call first to confirm dates and prices.

Incredible Adventures - 642-7378 or 1-800-777-8464
www.incadventures.com

These guys offer short trips at very reasonable prices. A two-day camping trip to Yosemite National Park, for example, is $170. They provide all the transportation, camping gear, and food. As for the rest, it's a cooperative experience: everyone helps to set up camp, prepare food, and clean up. If you don't have a sleeping bag they can rent you one for $10. Their other destinations include: Muir Woods and wine country, the Grand Canyon, Bryce Canyon, Zion Canyon, and Lake Tahoe.

Greyhound - 1-800-231-2222

www.greyhound.com

I always feel sick to my stomach when I travel by bus, which is unfortunate, because it's a really inexpensive way to get around - particularly if you pre-plan your trip. Long-distance tickets, booked one week in advance and without stop-overs, are incredibly cheap. You can travel from San Francisco to New York for just $179. It takes almost 3 full days though, so you gotta have some time to spare. Greyhound also sells various passes which entitle you to unlimited travel - meaning that you can get on and off the bus as you please. If you just want to pop down to LA, it's $87 return and takes about 8 hours. All buses leave from the Transbay Terminal (425 Mission Street, at 1st and Mission), where they also book and sell tickets. Open: 5:30am-midnight.

AC Transit

www.actransit.org

This bus service connects the East Bay to San Francisco and runs from the Transbay Terminal at 1st and Mission to West Alameda and Contra Costa counties. For info call (510) 891-4777.

Golden Gate Transit

www.goldengatetransit.org

Golden Gate Transit provides bus service within Marin and Sonoma Counties (north of San Francisco) and Contra Costa County (east of San Francisco). Call 923-2000 for info.

drive-aways & ride sharing

If you're planning to head out on a long road trip, you might want to see if you can find a drive-away. That's when you deliver someone else's car to a particular destination and pay only for your own expenses and gas. Unfortunately, there are only a few places left where you can arrange a deal like this anymore. The most reliable one in this area is probably Auto Driveaway Company in Hayward (28402 Century St; 1-800-783-0119 or 510-782-4999; *www.driveawayco.com*). You'll have to pick up your drive-away car from their office, but you can get to Hayward by BART.

As for ride sharing, the bulletin board right inside the main door of Rainbow Groceries (see Food chapter) often has notices from drivers offering rides in exchange for gas money, companionship, or help with the driving on long treks. Most of the hostels (see Places to Sleep chapter) also have notice boards - try posting one of your own.

air travel

There are lots of cheap travel agents listed at the back of *The Guardian* and *The SF Weekly* (see How To Find Out Who's Playing, Music chapter), as well as in the travel section of the Sunday edition of the *SF Chronicle*. Shop around: sometimes you can find good last minute deals. The biggest **student travel agent** is STA (36 Geary Boulevard, 391-8407; and 530 Bush Street, suite 102, 421-3473). If you're calling, be prepared to wait on hold for some time before you get to talk to a live human.

If you're the type of footloose traveler who can handle landing in exotic locations with only an overnight bag, you might want to consider a courier flight. In exchange for your baggage space, you get mega-discounted tickets to places all over the world. Try the **Air Courier** Association (1-800-339-7556; *www.aircourier.org*). You have to become a member, which costs $49 for the first year, but you could save hundreds of dollars on airfare. Another source of info on courier flights is *www.rideguide.com*.

Another free-style way to travel is with **Airhitch** (1-877-AIR-HITCH; *www.air-hitch.org*). They offer cheap fares to destinations all over the world, but you have to be extremely flexible about your departure dates. Their website makes it all seem a bit complicated, but if you want to fly cheap, it's worth the effort.

getting to the airports

San Francisco International Airport (SFO)

www.sfoairport.com

The easiest way to get to and from SFO is to hop on BART (see Getting Around chapter) and get off at the SF International Airport Station. From there, an Airtrain (that circles the airport) will shuttle you to your terminal free of charge. The cost of the BART portion of your trip will depend on how far you travel, but to give you an idea, SFO to Embarcadero station is $4.95. The only bummer about the BART trains is that they stop running at around midnight, and on Sundays they don't start until about 8am. If your flight requires you to be at the airport at a time when taking BART isn't an option, there is a 24-hour bus service called Sam Trans that leaves from the Transbay Terminal (425 Mission Street, at 1st and Mission). This bus costs $3 and doesn't make any local stops. At the airport, you can catch Sam Trans into town from any of their well-marked stops outside of each terminal.

Oakland International Airport

www.flyoakland.com

Oakland Airport is about 45 minutes away from the Embarcadero BART station. At the Coliseum/Oakland Airport BART station you'll need to transfer to an airBART shuttle, and pay another $2. Tickets for the shuttle are available from a machine inside the station or, if you have exact change, you can pay the driver.

Door-to-Door Vans

A door-to-door van service is much more expensive than public transit, but cheaper than a taxi and is a good option if you're arriving very late at night or early in the morning. At the airport, you'll find them parked outside of every terminal. They usually cost between $14 and $18 per person. Sometimes you have to wait until your driver has enough passengers to make his trip worthwhile. If you need to be picked up in the city and delivered to the airport, Supershuttle is a reliable company (558-8500).

maps & travel books

Get Lost Travel Books
1825 Market St (btwn Guerrero & Valencia; Laguna & Octavia), 437-0529

www.getlostbooks.com

A cool store with a great name, but no relation of ours. This is the best place in town to visit for inspiration or for supplies: travel literature and guides; maps to admire and maps to use; travel journals and travelers' gadgets. You'll also find luggage and money belts. At their free weekly events - talks and slide shows - you'll meet other travelers and are sure to learn something interesting. Their website is full of great info, too. Open: mon-fri 10-7; sat 10-6; sun 11-5. (Fillmore)

day trips & overnight jaunts

Angel Island

Angel Island (*www.angelisland.org*) is the biggest one in the San Francisco Bay and a day trip here is an easy way to briefly escape the bustle of the city. There are a number of historical sites on the island (mostly ruins of old military forts from different eras), and some beautiful beaches. With only 13 miles of road on the whole island, it's ideal for hiking or biking. Blue & Gold ferries to Angel Island depart from Pier 41 (mon-fri at 10am; sat/sun 9:45am; 11am & 2pm). Returning ferries are from 3 to 4 hours later and the fare is $13.50 round trip. Bikes are allowed free of charge. You can also camp on the island, but the campsites are often booked up far in advance (call 1-800-444-7275 to reserve). During the week you might get lucky, though, and score one just by showing up early. Watch out for raccoons. While you're sleeping they'll go for any food that's not securely stored. Call 435-1915 for lots of recorded information about the island.

Berkeley

Berkeley is just a hop, skip and a jump away from San Francisco, and it's very easy to reach by BART (see Getting Around chapter). There's a whole other universe over there - with enough cool places to fill a book of its own. For shopping, stroll down Telegraph Avenue, and be sure to stop at Moe's, an amazing bookstore located at 2476 Telegraph Avenue (btwn Hastings & Dwight; *www.moesbooks.com*; open 10am-11pm daily). The University of California, Berkeley, is located at the top of Telegraph Avenue, and it's a beautiful campus to wander through. If it's a pint and some live music that you're in the mood for, check out The Starry Plough, 2 blocks east of the Ashby BART station (3101 Shattuck at Prince; *www.starry-ploughpub.com*; 510-841-2082). But for something edgier, head for the famous punk club, 924 Gilman Street. Bands play on Friday and Saturday nights. It's located at, um, 924 Gilman Street, at 8th, in North Berkeley (tel: 510-525-9926; *www.924gilman.org*). It's an all-ages music and performance venue, which means that they don't serve alcohol. The punk club is a couple of miles from the North Berkeley BART station, but all of Berkeley is incredibly bike-friendly and it's easy to bring your bike from San Francisco on BART (See Getting Around chapter).

Marin Headlands

The hills that you see across the San Francisco Bay are part of the Marin Headlands. There are many miles of great hiking over there and many interesting places to visit. One of my favorite spots is the Point Bonita Lighthouse - an active lighthouse that can only be reached by a steep trail. It's thrilling to stand on the very edge of a cliff with the Pacific Ocean right below. But note that you can only access the area from 12:30 to 3:30 on Saturday, Sunday, and Monday afternoons. Strange as it sounds, Fort Cronkhite is another of my favorite destinations in the Marin Headlands. There are some beautiful trails here that wind past creepy

old army barracks that were carved into the cliffs during WW II and the Korean War. The beach here is also a very popular spot with surfers. The Marin Headlands Visitor Center (tel. 331-1540; *www.nps.gov/goga/mahe*), is located near Front Cronkhite and is open daily from 9:30-4:30. You can get to the Visitors' Center and points nearby by taking MUNI bus 76, but it only runs on Sundays, unfortunately. A bicycle ride out here is a great day trip. Ride across the Golden Gate Bridge on the right hand side. After the bridge, ride just a bit further and take the second exit, at Alexander Avenue. Then take the first turn-off on your left and ride through the tunnel. Don't worry, there's a bike lane. Follow the road, keeping to your right and avoiding all cut-offs. In about 2 miles you'll see signs for the Visitors' Center.

Point Reyes

Point Reyes is about an hour and a half north of SF and has beautiful hiking, beaches and wildlife. When you're tired of the gritty city and need to be in the woods, consider a visit to the American Youth Hostel at Point Reyes National Seashore. It's a fun, affordable getaway. The AYH (*www.norcalhostels.org*; 663-8811) offers dormitory-style sleeping arrangements and costs a mere $14 to $16 per night. The only way to get here, though, is by car, unless you're a real bicycle jock. It's located 8 miles from the Point Reyes Visitors' Center, off Limantour Road. From the flashing traffic lights in Olema, go north 200 yards on Highway 1, then turn left onto Bear Valley Road. Go 1.5 miles to the second left turn, then 5.5 miles to the first crossroad and turn left. (Point Reyes)

Stinson Beach

Stinson Beach is a popular beach for surfers and swimmers. It's located in Marin County - north of San Francisco and just south of the town of Stinson. On weekends and holidays you can get there with Golden Gate Transit bus 10 (see Buses, above). Catch the bus at: 7th & Market, McAllister & Polk, Geary & Divisadero, Geary & Arguello, or at the Golden Gate Bridge toll plaza. Ask for a transfer. When you get to Marin City change to bus 63, which will drop you at the Stinson Beach parking lot.

Mount Tampalpais / Muir Woods

West Point Inn

"Mount Tam" State Park (*www.parks.ca.gov*) is just north of San Francisco and it includes the famous Muir Woods redwoods, many amazing vistas, and miles and miles of hiking trails. The Muir woods portion of the park (*www.visitmuirwoods.com*) is open from 8am to sunset and there's a $3 admission fee. It's famous for its enormous and ancient redwood trees. There are campsites available on Mount Tam on a first-come, first-served basis (call 388-2070 for details). But my favorite way to spend the night here is to bed down at the hikers' cabin called the West Point Inn. It's only accessible by foot - 2 miles from the Pan Toll Ranger Station, along Old Stage Road. There is no electricity or restaurant up here, but the panoramic view of San Francisco and the Marin Headlands from the porch is outstanding.

There are seven rooms at the Inn and five rustic cabins nearby. The big community kitchen has all the essential cookware. Bring a book light if you want to do any night reading as the propane-supplied lights go out at 10pm. Mount Tam is a high fire zone so open flames are prohibited, and this includes candles. Hiking maps and drinks are available at the Inn. The lobby is also open to hikers passing by: summer 11am-6pm; winter 11am-5pm. Beds cost $35 per night. Call in advance to make a reservation (415-646-0702; open 24-hours).

It's possible to get to Mount Tam by bus, car, or bike. By bus (weekends only): take a Golden Gate Transit bus (70 or 80) from 7th and Market Streets. This bus will take you to Marin City. Transfer to bus 63. This will take you to the Pan Toll Ranger Station. By car: take Highway 101 North over the Golden Gate Bridge. Exit onto Highway 1. Follow the signs to Muir Woods. By bike: Take the Ferry to Sausalito (see above) and use a bike map to find the trail into Mill Valley from where you'll take West Blithdale Avenue to Mt. Tam. This is a serious bike ride and I only recommend it for ambitious cyclists who are not daunted by the thought of riding up a mountain.

Oaksterdam

Oaksterdam is the name of a once-blighted area of Oakland that's being revitalized by the cannabis-related businesses that have established themselves there - starting with a number of dispensaries (see Cannabis chapter) in the late '90s. Though it would be a stretch to call this area charming - think run-down low-rise office buildings - it is now a friendly area with a number of historical and architecturally attractive landmarks, pleasant parks, and plenty of tasty little eating spots. But one of the main reasons to visit is the historical significance of what's happening here - some day you might be able to tell your grandkids that you were there when prohibition started crumbling.

Start your visit at the Oaksterdam Gift Shop (405 15th St, btwn Broadway & Franklin; 510-836-4438; open: 11-6) or at their website (*www.oaksterdamnews.com*). There you can pick up free copies of *Oaksterdam News* - with a map of the area and eating recommendations in every issue.

The Co-op Stop (1733 Broadway Ave) sells vaporizers and issues I.D. cards to people with documentation to prove that they're qualified patients. The Bulldog Coffeeshop (1739 Broadway Ave) was one of the first dispensaries in the neighborhood - though now they serve cappuccinos and soy chai instead of buds. The dispensary tucked inside Coffeeshop SR-71 (377 17th St) is only open to I.D. holders. In the summer there's live music on their sidewalk out front every Sunday and you can get veggie meals and smoothies at The Fine Place right next door. Other outdoor hang-outs include: the roof garden atop Kaizers Parking Lot (across from 1950 Franklin) where there are picnic tables, canopies, vines and great a view of the district; Merrit Lake with its walking trail and huge variety of rental boats; and lovely Snow Park, just across the street from the lake.

And finally, it's a bit outside the area, but you might want to check out Heinhold's First & Last Chance Saloon (48 Webster St; 510-839-6761; *www.heinoldsfirstandlastchance.com*), which looks much the same as when Jack London used to hang there (and, incidently, was experimenting with hashish).

To get to Oaksterdam (the area bounded by Oakland City Hall & Lake Merit; Chinatown & Grand Ave), take BART to the 19th Street Station, or exit at the Civic Center Station and make your way toward 17th Street.

Practical Shit

tourist info

The Visitors' Information Center is located in Hallidie Plaza, at 900 Market Street, next to the Powell Street BART station, at Powell and Market streets (Civic Center). They provide a variety of services in many different languages. They have flyers and discount coupons for hotels, and the helpful staff at the counter can book a room for you. They also have lots of info on restaurants, museums, and other tourist attractions. They sell maps and various passes for public transportation (see Getting Around chapter). If you have a specific question, you can request info by phone during business hours - (415) 391-2000 - or try their website: *www.sfvisitor.org*. They are closed Thanksgiving Day, Christmas Day, New Year's Day, and Easter Sunday. Otherwise, open: mon-fri 9-5; sat/sun 9-3.

money

Foreign exchange bureaus are far more common in Europe than they are here in the US. If you're coming from abroad, it's easiest to leave all foreign currency in your home country and bring your **debit or credit card** (preferably both). ATMs (automated teller machines) are everywhere and most of them will allow you to withdraw US dollars against your own account at home, at a competitive rate of exchange. Of course, you should check with your own bank before leaving to be sure that they aren't going to gouge you for this service.

If you have **travelers' cheques**, the following places will cash their own cheques for free:

American Express Travel Service Center
455 Market (at 1st St), 536-2600; Open: mon-fri 9-5:30; sat 10-2.

www.americanexpress.com.

Thomas Cook Foreign Exchange
75 Geary Blvd (at Grant St), 362-3452; Open: mon-fri 9-5; sat 10-4.

www.us.thomascook.com.

phone

The area code for San Francisco is 415. For Oakland, Berkeley, and other points in the East Bay, it's 510.

For **international calls** dial 011 + the country code + the city code + the local number. Country codes are listed in the front of the white pages in the phone book. To make collect calls, dial 0 before the country code and number you are calling.

Pre-paid, long-distance **phone cards** are handy items when you're traveling. They're easy to use and work on all phones. They sell them at the Visitors' Center (see above), post

offices, and at corner stores all over town. They come in many denominations and have simple instructions on the back.

If you're here for a couple of months and want to get set up with cheap **voice mail** (a phone number where people can leave messages for you and you can retrieve them), call Bay-Link: 1-800-909-8439 (*www.bay-link.com*). They charge $12 per month with a one time set-up fee of $10.

mail

As we go to press, **postal rates** for regular-sized letters are as follows... Within the U.S: 39 cents (24 cents for postcards). For Canada and Mexico: 63 cents (50 cents for postcards). Everywhere else: 84 cents (70 cents for postcards). Calling 1-800-275-8777 will get you lots of taped info on postal rates, local post office hours, or zip codes. Or go to *www.usps.com*. Here are a few post office branches around town:

Upper Haight

554 Clayton (at Haight St). Open: mon-fri 9-5:30; sat 'til 4.

Mission

1198 South Van Ness (at 23rd). Open: mon-fri 9-5:30; sat 'til 3.

Castro

18th (at Diamond St). Open: mon-fri 9-5:30; sat 'til 4.

North Beach

1640 Stockton (at Filbert). Open: mon-fri 9-5:30; sat 'til 1.

Downtown

Federal Building (Golden Gate & Larkin). Open: mon-fri 8:30-5.

Union Square

170 O'Farrell St (inside Macy's). Open: mon-sat 10-5:30; sun 11-5.

You can have mail sent to you marked **'General Delivery'** (or *Poste Restante*) at the Civic Center Post Office Box Unit, P.O. Box 429991, San Francisco, CA, 94142-99991. You can pick it up at 101 Hyde Street (at Golden Gate). Remember to bring your passport. Open: mon-sat 10-2.

To ship stuff anywhere in the world, try P.O. Plus (584 Castro Street, at 19th; 864-5888; *www.poplus.com*). They offer full mail service and, if needed, they can pack your stuff as well. Open: mon-fri 9-6; sat 9-5.

To send or receive e-mail, check the Café sections of the district chapters (particularly Haight and Mission). The libraries also have facilities (see Hanging Out chapter).

weather

You can always spot tourists in San Francisco, particularly in the summer. They're the ones who are woefully underdressed, shivering in their shorts and t-shirts because they assumed that they're visiting sunny California where it's hot in the summertime. It's not - at least not in the city of San Francisco. While it may hit over 100 degrees inland during the summer months, here on the coast it tends to be shockingly chilly and foggy. Really. Brrrr. The hottest months in San Francisco are often September and October, though May and June are usually warm. The pay-off for the truly shitty summer weather are the very mild winters. It can be quite sunny and pleasant in January. Unless, of course, it starts raining and doesn't stop, but that's another story.

Another aspect of San Francisco's weather that often takes visitors by surprise is its "microclimates". These are tiny, localized weather patterns. This means that you could be eating a burrito in your t-shirt in the Mission (where it tends to be warmer and sunnier), and then - immediately afterwards - zip on over to Haight Street to do a little window shopping, only to find that it's foggy and 10 degrees colder there, and that you're going to freeze your butt off without a jacket. The fog can roll in mighty quick, too. You might head off to Baker Beach in the sunshine and by the time you've spread out the ol' towel and slathered on some sunblock, a wall of fog so thick that it completely covers the Golden Gate Bridge has rolled in. It's an amazing, yet frustrating, phenomenon. You always need to be prepared for these types of things here, and the only way to do that is with layers, layers, layers of clothing. Carry them with you and I promise, 9 times out of 10 you won't regret it.

public toilets

It can be a big drag to try to find a toilet when you're traveling in a strange city. Fortunately, there are some pay-toilet facilities around. They cost 25 cents, though, which is really annoying, but at least they're clean. Look for dark green kiosk-like things on selected corners. Strangely, they look just like the newspaper stalls. It's kind of an interesting experience. They're big and roomy and self-sterilizing. Do whatever you gotta do and get out, though, because in 20 minutes the door will open automatically. Oops!

Here are a few convenient sites:

Castro: Castro & Market.
Mission: 24th & Mission; 16th & Mission.
Downtown: Grove & Larkin; Powell & Market.
Upper Haight: by the park at Stanyan & Waller.
North Beach: by Washington Square Park, on Union.

drinking age

The legal drinking age in the US is 21. I know: it's hard to believe that Americans can vote and join the army years before they're allowed to order a beer, but it's true. Even if you look (or feel) much older than 21, be sure to bring identification of some sort with you whenever you go out to a bar. Most bars in the city close at 2am. By the way, it's illegal to drink in public places except at events where alcohol is being sold.

tipping

Service people in the US rely on tips to get by. The minimum wage in the service sector is so low that it's actually not possible to make ends meet without tips. Because of this it's customary to always leave something, and not to do so is considered very rude. In restaurants, the average tip is between 15 and 20 percent of the check (excluding tax). Taxis also expect 10 to 15 percent of the fare. At café counters it's not socially mandatory to put anything in the tip jar, but it's certainly appreciated.

smoking

California was the first state to make it illegal to smoke in public buildings. The idea is to protect employees from second-hand smoke. A few bars bend this rule, and if you see ashtrays around, you can probably smoke without getting into any trouble. But in the vast majority of bars and in *all* restaurants, shops and public buildings, smokers have to step outside to light up.

For the scoop on smoking **weed** in San Francisco see the Cannabis chapter, and the section on Oaksterdam in Day Trips (Getting Out of SF chapter). For smoking supplies visit one of the many head shops in the Haight.

gay & lesbian info

The Cool Guide has never included a chapter geared specifically towards lesbian and gay visitors to San Francisco. Instead, I've made a point of highlighting a couple of spots that cater to a mainly gay crowd in each section of the book (and any place that wasn't gay-friendly, wouldn't be listed anyway). However, to find out more about what's happening on the gay scene around town, I recommend the book *Betty & Pansy's Severe Queer Review* and a visit to the Lesbian, Bisexual, Gay, Transgender (LBGT) Center (see Three Dollar Bill Café, Castro chapter).

café jargon

C-c-coffee. Where would we b-b-be without it? We drink a lot of it here. In case you're not from a place with advanced coffee culture, here are a few terms to help you order your java:

Americana - espresso with a bit of hot water added.
Cappuccino - espresso with a little steamed milk and a lot of foam.
Latte - a tall glass of espresso with steamed milk and a little bit of foam.
Café au Lait - coffee and steamed milk.
Mocha - espresso with cocoa and steamed milk.
Mocha Blanco - espresso with white cocoa and steamed milk.
Snow Mocha - blended espresso, ice, milk and cocoa.
Depth Charge, a.k.a. Hammerhead or Red Eye - coffee with a shot of espresso.
Macciato - espresso with just a dollop of foam.
Florentine - coffee with steamed chocolate milk.
Con Pana - espresso with whipped cream.
Café Floor - a little bit of everything: espresso, coffee, steamed milk and foam.

If you have access to coffee-making equipment where you're staying and, like me, need a coffee before you can face going out for coffee, you'll want to know where to buy beans. One good place is the Castro Cheesery at 427 Castro Street, next to the Castro Theater (see Film chapter). Peet's Coffee and Tea is a local chain that has a few cafés sprinkled around town. They offer high quality beanage and a good strong brew. My favorite branch is the one in the Castro, at 2257 Market Street (between Noe and Sanchez).

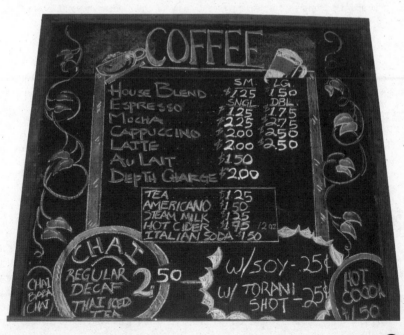

Food

This is truly the land of good food. Whatever kind you've got a hankering for, you'll find it in San Francisco. And you don't have to pay a lot to eat it. There are excellent low-cost restaurants serving a huge variety of ethnic food and good, wholesome California-style cooking throughout the city. There are also a very healthy number of vegetarian and vegan eateries. Restaurants and cafés are included in each of the district chapters.

farmers' markets

The best place to find fresh, seasonal, locally produced food is at the city's great farmers' markets. Often there are organic choices too. You can pick up healthy stuff at the following markets:

Civic Center - UN Plaza, Market St (btwn 7th & 8th)

Don't miss the Two Dog Farm stand (look for the tomato flag). Their tomatoes may be the best you'll ever eat. Open: year-round wed, sun 7-4. (Civic Center)

Ferry Plaza - in the Ferry Building, on the Embarcadero (at the foot of Market St)

This is an up-scale market with beautiful displays and lots of organic produce. Even if you can only afford to browse, it's a pleasant place to hang out. Open: apr-nov tues 10-2; sat 8-2; sun 10-2; may-nov thurs 4-8. (Embarcadero)

Noe Valley - btwn Sanchez & Vicksburg (in the parking lot)

If you're around Noe Valley (see Other Districts chapter) on a Saturday morning, it's worth dropping by this tiny organic market. There's live music from 10:00. Check their website - www.noevalleyfarmersmarket.com Open: year-round sat 8-12. (Noe Valley)

Alemany Market - 100 Alemany Blvd (near Hwy 101)

Those of you with access to a car might want to check out this long-standing, year-round market. On Saturdays you'll find the usual market fare, as well as Indian food and a cute little tamale stand. On Sundays there's no food available, but it's an interesting "Antiques and Collectibles" market, with used clothes, furniture, records and general bric-a-brac. Open: sat 6am-1pm; sun 7am-3pm. (Mission/Bernal Heights)

neighborhood produce shops

If you oversleep on the weekend and miss the farmers' markets, here are some areas with a good selection of fruit and veggies. In the Mission, there are quite a few classic family owned places on 24th Street between Folsom and Potrero. In Chinatown, Stockton Street is an amazing place to go for cheap produce, though the crowds can make it a pretty intense shopping experience. And in the Richmond, Clement Street has some awesome Asian supermarkets where you can find all sorts of fruit and veggies at cheap prices.

health food stores

Rainbow Grocery - 1745 Folsom St (at 13th), 863-0620

www.rainbowgrocery.org

This huge, worker-owned co-op stocks a selection that impresses even the most hard-core California health food junkies. You'll find tons of organic produce, a great cheese department, an amazing array of bulk items and all sorts of packaged goods. Rainbow Grocery also includes a "general store" which features a full range of homeopathic and natural body products. Parking is free, or you can take Bus 12 and get off near the highway underpass. Open: daily 9-9. (Mission)

Real Foods - 2140 Polk St (btwn Broadway & Vallejo), 673-7420;
3060 Fillmore St (at Filbert), 567-6900

www.realfoodco.com

The Real Foods shops are more expensive than Rainbow, but they're also very well-stocked and are in a couple of convenient locations. Open: daily 9-9. (Haight-Ashbury, Marina)

Harvest Ranch Market - 2285 Market (at Noe), 626-0805

This natural food store has the most amazing salad bar I've ever seen in my life. It includes surprises like sushi and noodles in peanut sauce. Yum. Be prudent with your choice of toppings though, because they charge by the pound. There are also excellent homemade soups on offer. Take your food to one of the benches outside to experience the Castro while you nosh. Open: daily 8:30am-11pm. (Castro)

pizza slices

There's pizza everywhere in San Francisco, but here are a few particularly cheap places where you can get delicious slices.

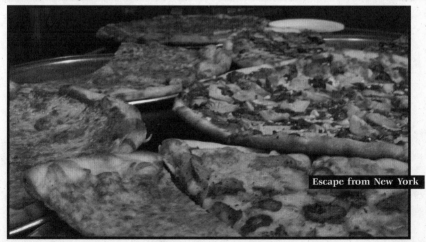

Escape from New York

Escape from New York

Try the potato with chunks of garlic. Good, thin crust. Order online (*www.escapefrom-newyorkpizza.com*). Free Delivery!

1725 Haight St (btwn Cole & Shrader), 668-5577. Open: sun-thurs 11-midnight; fri/sat 11-2am. (Haight-Ashbury)

508 Castro (btwn 18th & 19th), 252-1515. Open: sun-wed 11:30-midnight; thurs-sat 11:30-2am. (Castro)

333 Bush St (btwn Montgomery & Kearny), 421-0700. Open: mon-fri 9:30-6:30; sat/sun 11-3am. (Financial)

Arizmendi Bakery - 1331 9th Ave (btwn Irving & Judah), 566-3117

Gourmet pizza. Thin crust. People line up for these. Check their website (*www.arizmendibak-ery.com*) to see the pizza of the day or to reserve a pie (see Richmond chapter). Open: tues-fri 7-7; sat 8-7; sun 8-4. (Richmond)

Golden Boy - 542 Green St (btwn Columbus & Grant), 982-9738

Thick, crusty Sicilian slices. Open: sun-thurs 11:30-11:30; fri/sat 11:30-2am. (North Beach)

Marcello's - 420 Castro (near Market), 863-3900

A good gourmet slice, with thick *or* thin crust. Open: sun-thurs 11:30-11:30; fri/sat 11:30-2am. (Castro)

North Beach Pizza - 1499 Grant (at Union), 433-2444

Pizza, pasta, salads and sandwiches, all reliably good. Free delivery. Order online - *www.northbeachpizza.com*. Open: sun-thurs 9am-1am; fri/sat 9am-3am. (North Beach)

Panhandle Pizza - 2077 Hayes (btwn Clayton & Cole), 750-0400

Yummy cornmeal crust, unique toppings and vegan options. Open: daily 4pm-11pm; fri also 11:30pm-2:30am. (Haight-Ashbury)

Serrano's - 3274 21st St (btwn Valencia & Mission), 695-1615

Get a slice as big as your face for only $2.50. Open: sun-thurs 11-midnight; fri/sat 11-1am. (Mission)

Volare - 456 Haight St (btwn Fillmore & Webster), 552-2999

Big, cheesy slices for only $2. Open: daily 4pm-2am. (Lower Haight)

Zante's Indian Cuisine and Pizza - 3489 Mission St (at Cortland), 821-3949
3083 16th Str (btwn Mission & Valencia), 621-4189

Indian pizza. An unlikely cultural combo, but it really works. Open: daily 11-11. (Bernal Heights; Mission)

burritos

This is one of the few times in your life that it's okay to eat something the size of a chihuahua. Don't leave town without trying one. They're nutritious, delicious, cheap and guaranteed to fill you up. Veggie burritos tend to be in the $4 range, and you get your choice of guacamole and/or sour cream, hot or mild salsa, and whole, refried or black beans. "*Carne asada*" is a popular burrito that consists of chopped, marinated beef. For you adventurous meat-eaters out there, it's sometimes possible to order brains or tongue in your burrito or taco, but you're definitely on your own researching that one. There are good Mexican restaurants scattered around the city but the Mission district is the place to go to get the most burrito for your buck.

Taqueria CanCun - 3211 Mission St (at 26th), 550-1414; 2288 Mission (at 19th), 252-9560

Extremely cheap, hearty burritos and free chips and salsa with every order. Open: sun-thurs 10-1; fri/sat 10-3. (Mission)

Pancho Villa - 3071 16th St (at Valencia), 864-8840

Cheap and exceptionally huge burritos served in a cheap and exceptionally huge taqueria. Open: daily 10-midnight. (Mission)

El Faralito - 2779 Mission St (at 24th), 824-7877

An authentic Mission experience. Open: sun-thurs 10-1am; fri/sat 10-3am. (Mission)

El Toro - 598 Valencia St (at 17th), 431-3351

Offers a large vegetarian selection. Try the spinach tortilla. Open: daily 10-10. (Mission)

Balazo - 1654 Haight St (at Belvedere), 864-2140

Features a "Jerry's Burrito" with cactus and Mexican goat cheese that's very good. The "Super Veggie Nachos" are yummy and feed two. Open: daily 10-10. (Haight-Ashbury)

falafel

They come wrapped up burrito-style in these parts. Here are just a couple of the local favorites:

Ali Baba's Cave - 531 Haight St (btwn Fillmore & Steiner), 255-7820
799 Valencia (at 19th), 863-3054
Try a falafel with roasted eggplant and potatoes. Open: fri/sat 11-2am; sun-thurs 11-midnight. (Lower Haight; Mission)

Truly Mediterranean - 3109 16th St (near Valencia), 252-7482
Truly awesome falafel. Open: mon-sat 11-midnight; sun 10-10. (Mission)

sushi

For reliably delicious sushi, try:

Balboa Sushi House - 402 Balboa St (btwn 5th & 6th), 386-3769
A mom-and-pop place with house plants galore. Open: mon-sat 11:30-11; sun 5-10. (Richmond)

Country Station - 2140 Mission St (at 18th), 861-0972
Funky and friendly. Great vegetarian options. Ramshackle atmosphere. Open: mon-thurs 5:30-10; fri 5:30-11. (Mission)

Isobune Sushi - in the Japan Center, 563-1030
Not particularly cheap, but a fun sushi experience. Sit at the counter and grab plates off little boats as they float past. Open: daily 11:30-10. (Japan Center)

Yokoso Nippon - 253 Church St (btwn Market & 15th)
Referred to as 'no name sushi' because there's no name on the building. Excellent, super cheap, and they have the best vegetarian options I've ever seen. (Mission)

We Be Sushi
538 Valencia St (btwn 16th & 17th), 565-0749; 1071 Valencia St (at 22nd), 826-0607
Very popular local chain with fast service and excellent miso soup. Open: mon-fri 11:30-2:45, 5-10; sat/sun 5-10. (Mission)

happy-hour food

Bottom of the Hill - 1233 17th St (at Missouri), 621-4455

www.bottomofthehill.com

In addition to being a great place to see up-and-coming bands (see Music chapter), this place lays on a very cheap, all-you-can-eat BBQ on Sunday afternoons starting at 4:30. (Potrero Hill)

The Tonga Room - basement of the Fairmont Hotel (at California & Mason), 772-5278
www.tongaroom.com

This South Pacific Tiki bar has been around forever and it's famous for its "hurricane". Every half hour there's a pseudo-tropical rainstorm in the big pool in the center, complete with thunder and lightening. Go during happy hour (week nights 5-7) and for $7 you can chow down at the all-you-can-eat buffet. But don't try to share a plate, 'coz the waitrons keep a sharp eye out for freeloaders like you, buddy! They require you to buy at least one fruity drink with a little umbrella in it, and this is the big bummer about the Tonga Room: those stupid drinks are really expensive. For a silly few hours out on the town, The Tonga Room is a classic and it's worth seeing. But you don't need to spend too much time (or money) here. Check out the lobby of the Fairmont as you come in. It was built in 1907 (the year after the big quake) and the plush red seats and marble columns give you a taste of San Francisco's former glamour. Open: sun-thurs 5pm-11:45pm; fri/sat 5pm-12:45am. (Nob Hill)

El Rio - 3158 Mission Street (half a block from Cesar Chavez), 282-3325
www.elriosf.com

Free, raw oysters are served on their cozy back patio (see Mission chapter) every Friday from 5pm until they run out. Get there early. (Mission)

Goat Hill Pizza - 300 Connecticut Street (at 18th), 641-1440
www.goathillpizza.com

Named in honor of the goats they used to keep in the backyard, this is a fun, friendly place, with highly palatable pies. On Monday nights, from 5 to 10:00, there's an all-you-can-eat pizza and salad bar for $9.50. Not super cheap, but not a bad deal, either. (Potrero Hill)

Openings

Gallery openings are often held on Wednesdays and Thursdays. Free wine, cheese and art - what more could you ask for? For info cruise The Guardian (see How to Find Out Who's Playing, Music chapter).

late-night eating

Bagdad Café - 2295 Market St (at Noe), 621-4434

This friendly diner has an atmosphere that's easy to take if you've been out too late. Try the spicy desert fries with ranch dressing: hot and a lot. Open: 24-7, that's all the time, everyday. (Castro)

Orphan Andy's - 3991 17th St (btwn Market & Hartford), 864-9795

The American diner food here is just so-so, but they're open all night. Climb into one of the big vinyl booths with your friends or belly up to the counter. Be prepared to wait for service. Open: 24 hours. (Castro)

Sparky's - 242 Church St (btwn Market & 15th), 626-8666

A '90s chrome diner. The exhausted, pierced and tattooed wait-staff often play loud rock 'n' roll in the wee hours. Free delivery! Open: 24 hours. (Mission)

The Lucky Penny - 2670 Geary Blvd (at Masonic), 921-0836

This is not the place to go if you want a trendy scene. It's just a regular ol' kinda-garishly-colored diner with breakfast served 24 hours. Has that "any-town USA" feel that can be so strangely comforting at 4am after too much partying. You're better off going by bike or car though, as the 38 Geary bus is very sloooow. (Western Addition)

It's Top's Coffee shop - 1801 Market St (at McCoppin), 431-6395

Well, it's not open 24 hours like the places listed above, but it is open very late. This is a '50s diner, with a doo-wop music jukebox at your booth (bring quarters) and smiling waitresses in little pink outfits. Excellent pancakes and milkshakes. Open: mon,wed,fri 8am-3pm and 8pm-3am; sat 8am-3am; sun 8am-11pm. (Fillmore)

24-hour supermarkets

I'm not really interested in promoting these big chains, but if you get in a jam late at night and need a giant, American-style supermarket...

Safeway

2020 Market, at 14th & Church (Castro); 3350 Mission, at 30th (Mission); 15 Marina Boulevard at Laguna (Marina)

Cala

4201 18th, btwn Collingwood & Diamond (Castro)

Food Not Bombs

www.sffoodnotbombs.org

This group distributes free food in public places in order to draw attention to and protest the existence of hunger in one of the wealthiest countries in the world. Most weekday nights they serve up vegan dinners at the U.N. Plaza (Market St & 7th) and they're often at political events - feeding many a hungry and tired protestor. If you're interested in volunteering, call 820-1540 or e-mail sffnbvolunteers@riseup.net.

Museums

Here's some basic information about San Francisco's biggest and most famous museums. Many of them are free or less expensive on either the first Tuesday or Wednesday of the month. The museums in Golden Gate Park are located in the Concourse on Tea Garden Drive, between John F. Kennedy and Martin Luther King Jr. Drives (near Fulton & 10th). There's a free Park shuttle bus that operates from 10 to 6:00 on weekends and holidays. It starts at McLaren Lodge, at Stanyan Boulevard and Fell Street, and the Beach Chalet, at Ocean Beach. It stops at many different sights within the Park, including the museums. See *www.goldengateparkconcourse.org* for more info. You can also pick up promo flyers for most of the big ones at the Visitors' Information Center (see Practical Shit chapter). I've described some of the more unusual museums further along in the chapter.

Alcatraz

www.nps.gov/alcatraz

"The Rock" used to be home to tough guys like Al Capone and Machine Gun Kelly. A lesser know fact is that it was occupied by Native Americans from 1969 to 1971. It's one of those tourist attractions that people who live here never go to unless they have out-of-town visitors, but then they're really psyched they did. Rent the audio tour, which adds a whole new dimension to understanding what life was like inside this famous prison. The total cost is $16 (with audio) and you can hang out for a few hours on the island. Night tours are also offered. See their website for details. In high season you'll need to buy your tickets in advance - call 705-5555. Blue & Gold Ferries leave frequently from Pier 41 (see Getting Out of SF chapter). The island closes at 6:30pm in the summer and 4:30pm the rest of the year.

Alcatraz

Asian Art Museum - 200 Larkin St, Civic Center Plaza (btwn McAllister & Fulton), 581-3500

www.asianart.org

Admission is $10 for adults, $6 for students, and $5 for everybody after 5pm. Free on the first Tuesday of every month. Open: tues-sun 10-5; thurs 'til 9. (Civic Center)

California Academy of Sciences - 875 Howard St (btwn 4th &5th), 321-8000

www.calacademy.org

This building includes the Steinhart Aquarium and the Naturalist Center. The location is temporary while renovations are being completed on its permanent site in Golden Gate Park (scheduled for 2008). Admission is $7; students, $4.50. But it's free on the first Wednesday of each month. Every third Thursday of the month admission is $5 and from 5 to 9:00 you can sip cocktails and listen to live Brazilian music while hanging out with the fish at the aquarium. Open: daily 10-5; thurs 'til 9. (South of Market)

California Palace of the Legion of Honor
Lincoln Park (off 34th & Clement), 863-3330

www.thinker.org/legion/index.asp

Don't let the name fool you, this Fine Arts museum is neither boring nor militaristic. It displays European art in a beautiful building in a stunning location. When you've had enough of the art, take a walk outside and catch the excellent view of the bay and the Golden Gate Bridge. Admission is $10; free every tues. Open: tues-sun 9:30-5:00. Accessible via MUNI buses 1, 2, 18 and 38. (Lincoln Park)

Coit Tower - Telegraph Hill, 362-0808

The lobby here is decorated with murals that were painted during the depression. The tower itself was built as a memorial to volunteer firemen (hence its fire-hose-like shape). Go in and check out the funky murals, but don't bother paying the couple of bucks to climb the stairs. The view from outside is just as good. Open: daily 10-5. (Telegraph Hill)

De Young Museum - 50 Hagiwara Tea Garden Drive (in Golden Gate Park), 863-3330

www.deyoungmuseum.org

De Young Museum

After the building that housed the De Young Museum of Fine Arts was damaged in the 1989 quake it took them years to build this new, very modern one with textured copper all over the outside. At the eastern end is a big, twisty tower with an observation deck that offers a panoramic view of Golden Gate Park and the city. You can go up in the tower for free. Admission to the museum is $10; free every first Tuesday of the month. Show a MUNI transfer or Fast Pass (see Getting Around chapter) for a $2 discount. (Golden Gate Park)

Exploratorium - Palace of Fine Arts, 3601 Lyon St (btwn Marina & Lombard), 397-5673

www.exploratorium.org

The Exploratorium is a museum full of interactive science and art exhibits. Admission is $13; students, $10; free for everyone on the first Wednesday of every month. Accessible via MUNI buses 28, 29, 30, and 43. By bike, it's two miles from Fisherman's Wharf on an easy, scenic route. Open: tues-sun 10-5; and occasionally on holiday Mondays. (Marina)

Museum of Modern Art - 151 3rd St (btwn Mission & Howard), 357-4000

www.sfmoma.org

Admission is $12.50 for adults; $8 for seniors; $7 for students. Thursday evenings from 6 to 9:00 admission is half price, and the first Tuesday of every month is free. Summer hours: daily 10-6; thurs 'til 9. Winter hours: 11-6; thurs 'til 9; and closed wed. (South of Market)

the unusual ones

Antique Vibrator Museum
603 Valencia St (at 17th), 522-5460; 1620 Polk St (at Sacramento), 345-0400

www.goodvibes.com

Did you know that vibrators were first used by doctors to treat hysteria? And that later they were marketed as a home appliance to keep women healthy and glowing? The Vibrator Museum includes the models that some famous women throughout the past century might have owned. It's the smallest museum in this guide, but it's a very interesting one. The display is located inside Good Vibrations (see Sex chapter), near the middle of the store, in tall, glass cases. See their website for more on the history of the vibrator and read about "the miraculous healing force of massage when rightly applied". Open: sun-wed 11-7; fri/sat 11-8. (Mission)

Cable Car Barn and Museum - 1201 Mason St (at Washington), 474-1887

www.sfcablecar.com/barn.html

San Francisco is famous for its cable cars, and at this museum you can learn how these babies work. Historic photos of the city are also on display, as well as an exhibit about earthquakes. Admission is free. Open: daily 10-5 ('til 6pm apr-sept). (Nob Hill)

Camera Obscura and Holograph Gallery
1096 Point Lobos Ave (at Great Highway), 750-0415

www.giantcamera.com

Camera Obscura and Holograph Gallery

This place is a favorite of many locals and when it was threatened with eviction recently there was a great outcry. The gallery itself actually **is** a giant camera obscura and what you'll see when you step inside is a hyper-real version of your surroundings. Sand, the Pacific Ocean, Seal Rock and surfers are projected from a rotating camera on the roof onto a white platter inside the building. It's mesmerizing. To find the Camera Obscura, turn right at the bottom of Golden Gate Park (with the Pacific Ocean in front of you) and climb the hill from Ocean Beach to the Cliff House. There are stairs next to the Cliff House bar that will take you around back, where you'll find this little structure. Admission is $3. Open: daily, weather permitting, 11-5. (Richmond)

Cartoon Art Museum - 655 Mission St (near New Montgomery), 227-8666
www.cartoonart.org

If you're into comics, cartoons and animation, you'll definitely want to go to this place. They have comic books and strips of all sorts, illustrations, and original art from editorial cartoons. They also host special artist-in-residence events. Admission is $6 for adults, $4 for children, and the first Tuesday of every month is "Pay What You Wish" day. Open: tues-sun 11-5. (South of Market)

The Chinese Historical Society of America
965 Clay St (btwn Washington & Sacramento), 391-1188

www.chsa.org

The permanent exhibit here tells the history of Chinese people in America. Changing exhibitions and special events focus on specific themes. There's also a well-stocked bookstore. Adults $3. Open: tues-fri 12-5; sat/sun 12-4. (Chinatown)

The Columbarium - 1 Loraine Court (btwn Stanyan & Arguello, Geary & Anza), 752-7891

San Francisco is a city without cemeteries. At the beginning of the 1900's a law was passed prohibiting burials within city limits, and then later almost all of the graves were relocated to the nearby town of Colma. Now there's more dead people than living ones in Colma, and the Columbarium is one of the few places left for the dead in San Francisco. It is over 100 years old and houses the cremated remains of over 30,000 people. It's a round, neo-classical structure with incredible stained glass windows and a very fancy domed roof. The urns are displayed in a sort of "honeycomb" of glass-covered niches. A few of the names are of famous San Francisco families, but many seem to be just regular folks who paid a lot to have their loved ones' ashes kept here. Some of the urns show a sense of humor: look for the old tobacco canisters, the glass cookie jars and the big ceramic baseball. Supposedly, the caretaker once saw the ghost of a little girl whose ashes are here. It's sort off a creepy place, but in a strangely beautiful way. Open: mon-fri 10-5; sat/sun & holidays 10-7. (Richmond)

Free Walking Tours - City Guides, 557-4266

www.sfcityguides.org

City Guides is a non-profit, volunteer-run organization, sponsored by the Public Library. Almost every day of the year you can join a free, guided tour of various San Francisco sites, from famous and infamous neighborhoods to hidden rooftop gardens and historic brothels. Walks vary in length and walkers meet their guide at the spot designated by the tour schedule. No reservations are required. Pick up their schedule at any library or at the Visitors' Information Center (see Places to Sleep).

Galeria de la Raza - 2857 24th St, 826-8009

www.galeriadelaraza.org

This non-profit community arts organization hosts high-quality exhibitions by Latino artists. Admission is free. The gallery is located next to Studio 24, a Mexican folk art bazaar, which is a good place to check out in the fall when they sell the figurines used to decorate for the Day of the Dead (see Hanging Out chapter). Open: wed-sat 12-6. (Mission)

Golden Gate Fortune Cookie Company
56 Ross Alley (btwn Grant & Stockton, Washington & Jackson), 781-3956

www.sanfranciscochinatown.com/attractions/ggfortunecookie.html

Take a free tour of this cookie factory and learn just how they get those teeny little slips of paper in there. You'll be allowed to sample some warm and freshly folded cookies, too. Leave with a big bag of them ($3 for 40 cookies), or arrange for your very own message to appear in a cookie ($16 for 100). By the way, the alley where this place is located, is the oldest alley in San Francisco and was once famous for it's brothels and gambling. Open: daily 7am-8:30pm. (Chinatown)

Lost Art - 245 South Van Ness Ave, Suite 303 (at 13th St), 861-1530

www.lostartsalon.com

Every inch of the space in this comfy loft is filled with treasures by little-known or completely unknown 20th-century artists (1900 to 1960). You'll find original period paintings, drawings and objects of art. The gallery has a warm, comfortable, salon-like feel. The owners are happy to talk about their philosophy or about individual pieces and artists. You can poke around the gallery or sit on one of the comfortable chairs and take it all in. Open: tues-fri noon-6:30pm; and every first sat of the month 11am-4pm. (Mission)

Maritime National Historic Park - Aquatic Park, 561-7100

www.maritime.org/safrhome.html

This museum resembles a ship and includes video re-creations and interactive exhibits on maritime life. Admission to the museum is free, but there's a $5 fee to board the historic ships. Open: daily 10-5. (Aquatic Park)

Mission Dolores - 3321 16th St (at Dolores), 621-8203

www.missiondolores.org

This is the oldest building in San Francisco. The paintings on the ceiling were done by Native Americans way back in the 1700s. There's a small museum with stuff from the original mission, and an old cemetery with a lot of famous dead people in it. Adults pay $3 to get in. Open: daily 9-4. (Mission)

Musée Mécanique
Pier 45, Fisherman's Wharf (on the Embarcadero, at the end of Taylor St), 346-2000

www.museemecanique.org

Musée Mécanique

The Musée Mécanique is the world's largest collection of antique arcade machines and mechanically operated musical instruments. We're talking seriously low-tech, here. I still can't get over the fact that they moved this place away from its great location behind the Cliff House. Sad. However, I have to admit that they did a pretty good job setting up the new place. Admission is free, but bring lots of change so you can play with these precursors to pinball, video games and TV. For a quarter the mystery of "What the Belly Dancer Does on Her Day Off" will be revealed to you. Ooh la la. There's also an interesting photography and video display of San Francisco's history. Open: mon-fri 10-7; sat/sun 10-8. (Ocean Beach)

The Museum of the African Diaspora -
685 Mission St (at 3rd), 358-7200

www.moadsf.org

This is the first major museum in the world focused exclusively on the African Diaspora. Admission for adults is $12; students, $7. Admission to the museum store is free. Open: mon, wed-sat 10-6 (thurs 'til 8); sun 12-5. (South of Market)

Precita Eyes Mural Art Center - 2981 24th St (at Harrison), 285-2287

www.precitaeyes.org

The Mission district is famous for its funky, colorful murals. Check out 24th Street (btwn Bryant & York) and Balmy Alley (between 24th & 25th). Every Saturday and Sunday afternoon (at 1:30) the Precita Eyes Mural Art Center offers tours led by a professional muralist. First they present a slide show about the history and process of mural art creation and then they guide you through the district. The cost is $12 for adults, and no reservations are needed - just show up at the Center. (Mission)

Randall Museum - 199 Museum Way (off Roosevelt Way; under Corona Heights), 554-9600

www.randallmuseum.org

This museum caters to children, but it's fun for adults, too. It offers many 'hands-on' science exhibits, events and classes. After you visit the museum, take a walk up the hill behind it for a great view of the city. Admission is free. Open: tues-sat 10-5. (Castro)

Tattoo Art Museum - 841 Columbus Ave (near Lombard), 775-4991

This is supposed to be the "world's biggest collection of tattoo art". I'm not so sure about that, but it's fun to flip through the pictures of tattoos from bygone eras. There are also articles on historical tattoo artists that you can read while you're there. And if you're inspired, you might want to get one yourself at the tattoo parlor on the premises. Admission to the museum is free. Open: daily noon-4pm. (North Beach)

Cannabis

The unique music, art and culture of San Francisco has always been very much influenced by recreational drug use, and marijuana, being the most common of these drugs, has played an important role in its development. It still has a significant effect on the cultural and political life of the city. You're more likely to detect the scent of burning herb on the streets here than almost any other American city. Some of the best weed in the world is grown in northern California. The "Emerald Triangle" (Humboldt, Trinity, and Mendocino counties) is world famous for its quality buds.

Warning: people do still get busted in California. The fine for possession of less than 28.5 grams of marijuana is $100; and for hashish or larger amounts the fine is $500, plus possible jail time. (For more info see *www.chrisconrad.com*.)

the bullshit war on drugs

Millions of Americans smoke pot regularly and have done so for generations. Cannabis has been California's biggest cash crop for decades. If it were legalized, it would bring billions of dollars out of the state's underground economy, and into the natural economy. Instead, billions are spent each year in order to maintain the prohibition. The attitude that illicit drug users are out-of-control and not worthy of basic civil rights, is fostered and maintained by those who have much to gain by keeping these substances illegal.

Not one single death has ever been caused by cannabis consumption. And smoking pot is far less harmful to one's health than either of the United States' two most popular legal drugs: alcohol and nicotine. In fact, the only real threats that cannabis poses are caused by the fact that it's criminalized. Over 700,000 marijuana-related arrests are made annually in the US, and thousands of people are wasting away in prisons for non-violent crimes - growing or using weed. More than 50 percent of the US federal prison population is currently doing time for drug-related offenses.

If you're interested in learning more about the human rights aspects of the War on Drugs, look for the informative and moving book *Shattered Lives: Portraits From America's Drug War* by Norris, Conrad, and Resner. Their website address is: *www.HR95.org*. See also *www.drugwarfacts.org* and *www.stopthedrugwar.org*.

There are many organizations of cannabis activists who are working towards legalization in the US, for example: The Marijuana Policy Project (www.mpp.org); and the Cannabis Consumers Campaign (*www.cannabisconsumers.org*).

medical marijuana

The effectiveness of cannabis as a treatment for a wide variety of health problems and disorders is well documented. In fact, it's been used for thousands of years in all parts of the world. More recently, it's been found to be particularly effective as a treatment for the vomiting and nausea brought on by chemotherapy, and as an appetite stimulant for people suffering from the symptoms of AIDS. But people who choose to treat their illnesses with cannabis in the US have to obtain it illegally and risk high fines, loss of property, and long prison sentences. The first voter initiative protecting the use of medical marijuana, Prop P, was passed in San Francisco in 1992. The statewide version, Prop 215, passed in 1996.

Over the past decade, however, several states have followed California's lead and passed Compassionate Use Acts. These laws are intended to enable patients, with their doctor's approval, to cultivate or purchase cannabis for medicinal use without fear of prosecution. But while cannabis activists have been winning some important battles on the medical front, there's still a long way to go before all cannabis use - industrial, recreational and medicinal - is legalized in the US. If you're interested in learning more about the medicinal properties of cannabis sativa, read *Hemp for Health* by Chris Conrad.

dispensaries

Dispensaries provide medical marijuana to patients of California-licenced doctors who have been recommended cannabis for the treatment of their symptoms. They are historic landmarks in the battle to legalize cannabis for medicinal use. They're not authorized under federal law, but when the California state legislature passed SB 420 (yes, really) in 2003, a defense was created that enables them to operate within certain limits. While the weed on offer is often not much cheaper than what one could find on the street, the dispensaries provide a safe and supportive environment for patients to buy and consume their medicine. Also, they don't just sell buds: there's an awesome variety of delicious cannabis edibles available now too - particularly important for those with lung and throat problems. In San Francisco alone there are approximately 35 "cannabis clubs" (though the number fluctuates as regulations evolve). Unfortunately, however, you won't be able to visit or buy weed at any of these clubs unless you've got a special patient ID card indicating that you have a recommendation from a California physician. Dispensaries and County Health Departments issue local cards, but the most popular is the one from the Oakland Cannabis Buyers' Cooperative (*www.rxcbc.org*), which is recognized at clubs throughout the state (about 150 in 2006).

With over a decade of experience regulating cannabis dispensaries, many people in the Bay area are prepared to move ahead with broader reform. In 2004, Oakland voters passed Measure Z with over 65% in favor of regulating marijuana sales for adults. Backers visualize Dutch-style cannabis coffeeshops opening in the near future, and hope that Measure Z will play the same role that Prop P did as a catalyst for reform. Part of Oakland has even acquired the name "Oaksterdam" (see Day Trips, Getting Out of SF chapter).

Hanging Out

S an Francisco is a great city for hanging out: it has some of the most beautiful nature of any city in the world; giant hills that afford amazing views; lots of free street parties, fairs and festivals; and Golden Gate Park - one of the most famous city parks in the US. However, as in most big cities, you should avoid hanging out alone at night in remote places.

parks

Golden Gate Park

It's hard to believe that this vast, lush park was once just a big ol' pile of sand, but it was, until a fellow named John McLaren came along and planted over a million trees, acres of grass and a huge array of plants. Due to its enormous size, you might want to explore the park by bicycle or inline skates (see Getting Around chapter). Sunday is the best day to hang out because then there are no cars allowed until 6pm. The paved roads will take you past some excellent museums (see Museums chapter), gardens (see below), lakes, ponds and meadows. The dirt roads will take you into beautiful nature areas. If you follow JFK Drive, you'll eventually reach the field where the buffalo roam. There are pedal boats (call 752-0347 for rental info) and bikes at the Stow Lake boathouse (opposite 17th Ave on Stow Lake Drive - see Getting Around chapter, Bikes section). There is a free shuttle that picks up passengers at 15 different locations around the park at 15 minute intervals (weekends & holidays, june-oct, 10am-6pm). At the top of the Park you can get on at McLaren Lodge (at Stanyan St), and at the other end (Ocean Beach) you'll find a stop at the Beach Chalet.

The Presidio

This historic military area dates back to 1776, when the Spanish were hanging out in this part of the world. Occupying a huge portion of the Northwest corner of the city, the park has miles of beautiful hiking and biking trails, as well as historical remnants of its military past. You'll find batteries to the west where various armies once defended the coast. Chrissy Field, bordering the Presidio to the north, was recently restored and native plants were reintroduced. It's a beautiful spot to walk along the water. The Warming Hut at Crissy Field (at the foot of Torpedo Wharf) is a good place to pick up a guidebook and a map or a sandwich and cappuccino (open: daily 9-5; 561-3042). The hut is made from 'green' products and recycled materials and much of the food is locally grown and organic. Pick up a snack here or bring your own picnic to the tables outside. There's a magnificent view of the Bridge, the city, and the bay from here. (Presidio)

Dolores Park - btwn 18th & 20th; Church & Dolores

Loungers and athletes mingle harmoniously at this fabulous city park. The ridge of the park (20th St side) is where most of the serious sunbathing happens and it attracts a large gay population. It also provides one of the best views of the city. You can sit on a bench and watch the fog roll in during the late afternoon, or enjoy the twinkling of city lights and the Bay Bridge at night. Below the ridge is the children's playground and on the 18th Street side you'll find tennis courts and a soccer field. It's a popular park with dogs and their walkers in the morning and late afternoon. Dolores Park is also the gathering place for many political demonstra-

tions and cultural events: anti-war marches; the Dyke march; the political theater of the SF Mime Troupe every 4th of July; the San Francisco Symphony; The Sisters of Perpetual Indulgence's "Easter Hunky Jesus" contest; and outdoor movies. Check it out. (Mission)

Alamo Square

Alamo Square - btwn Scott & Steiner; Fulton & Hayes

This is a sweet little park with a beautiful view. The famous "Painted Ladies" - a row of Victorian houses immortalized in many photographs - are on the Steiner side. Check out the tiny "shoe garden" - made of old shoes. There's also a tennis court here that's available on a "first come, first served" basis. (Fillmore)

Washington Square Park - btwn Union & Filbert; Stockton & Powell

Located in the heart of North Beach, this park is a great place to sit and read, sunbathe, picnic, or just people-watch after a big meal in a nearby restaurant. Unlike most of San Francisco's other parks, it's not situated on a hill, but instead feels like an old town square of the type more commonly seen in East Coast and European cities. (North Beach)

Fisherman's Wharf

This is a much over-rated waterfront development for tourists, but there are a few sites down here worth seeing. My favorite is the Musee Mechanique on Pier 45 (see Museums). You can also hang out and watch the stinky, honking seals bask in the sun off of Pier 39. It's interesting to smell them at night, too. Ferries to Alcatraz, Angel Island (see Getting Out of SF chapter) and other points depart from Pier 41. (Fisherman's Wharf)

Aquatic Park - at the end of Polk St, behind Ghirardelli Square

Aquatic Park is one of the nicest places to sit in the late afternoon and watch the sunset. There's a small beach where you can watch swimmers doing laps in the bay, and boats sailing by. You can also walk from here to the tourist hell that is Fisherman's Wharf. Via this route you'll catch a glimpse of the *old* waterfront, where it's still a little rough around the edges and a honky-tonk atmosphere still lingers. (Marina)

awesome views

Twin Peaks

It's a long hike, but once you're up top you've got the whole city spread out under your feet. It's especially beautiful at night - though you'll want to bring a jacket because it tends to be windy. It's probably the best place in the city to make out in a car. (Twin Peaks)

Russian Hill

Parts of this district are really beautiful. If you're hiking around the 'hood, take a look around Jones and Vallejo, or Hyde and Green. There are some dead-end streets that end in steep staircases where you can get a great view of North Beach, Coit Tower and the Bay. The

famous curvy part of Lombard Street - with it's eight hairpin turns - is in the block between Hyde and Leavenworth. (Russian Hill)

Alta Plaza Park - btwn Clay & Jackson; Steiner & Scott

This park offers an incredible view of the Bay. I suggest sitting on the bench near Jackson and Pierce Street. From here you will definitely understand why San Francisco is considered one of the most beautiful cities in the world. (Pacific Heights)

Bernal Hill

From the top of Bernal Hill you can see the whole city, the East Bay, and far beyond. To get there follow Folsom Street past Precita Park and head uphill for about 3 blocks to the main entrance of Bernal Heights Park (see Other Districts chapter). There are dirt paths all over the hill and it's a very popular dog-walking spot. It's lush and green in the winter months, but turns a burnt-out brown in the summer. If you happen to be here in October, see if you can catch the illegal yet popular Soapbox Derby Race, when grown-ups and kids hurtle down the hill in homemade racers. (Bernal Heights)

Kite Hill

This place isn't as well known as Corona Heights, but it's nearby and it's got the same perfect, full-on view of the city and the Bay. This is how to get there... Head up 20th Street from Castro Street (away from the Mission). Walk four blocks then take a right on Douglas. One block to the right you'll find Seward Street. Look for the big cement slide! After you've gone up and down it a few times, walk up the stairs and take a left. The street dead-ends at Kite Hill. (Eureka Valley)

Buena Vista Park - off of Haight St; btwn Baker & Central

There are lots of paths that wind through the woods here and they'll take you to the top of the hill, which has a beautiful view and is a good place to watch the fog roll in. It also happens to be a popular gay cruising area so you might want to avoid the guys lurking in the bushes. Or you might not. (Upper Haight)

Corona Heights

Okay, I'm going to describe one of my favorite walks. Try it on a clear night to get the full effect. Start by walking up 17th Street, away from Castro and Market. Take a right on Ord Street and you'll pass the Saturn Steps on the left. Take a peek at them, but go one more block and walk up the Vulcan Steps (without bothering the people who live in the little cottages, of course). At the top of the steps, take a right on Levant - past the hairpin curve - to Roosevelt Way. One block to the right you'll find the entrance to Corona Heights. Catch the view from the top of the moon-rocks. It's a great little party spot. (Upper Market)

Sutro Baths

The view from these historic ruins (*www.nps.gov/goga/clho/suba*) is spectacular: cliffs, crashing waves, and stunning rock formations. The extravagant baths were built by a millionaire in the late 1800s and could accommodate thousands of warmth-seeking visitors. If you look in the lobby of the nearby Cliff House, you'll see photos of what the baths looked like during its heyday. It's a less glamorous destination these days, but it's still fun to wander around the ruins. Head into the tunnel where you can hear the roar of the sea as it slams against the rocks. It's not far from Ocean Beach (see below). There's a path along the cliffs above the ruins that's a beautiful route to the Legion of Honor (see Museums). Geary bus 38 will get you there.

gardens

Strybing Arboretum and Botanical Gardens - Golden Gate Park (9th & Lincoln)

www.sfbotanicalgarden.org

Travel the world without ever leaving the park. In these gardens you can stroll past rare plants and flowers from all over the planet. The Japanese "Moon-Viewing" rock garden and the "Garden of Fragrance" are particularly beautiful, peaceful places. Admission to the Arboretum is free, and free guided tours depart daily at 1:30 from the bookstore just inside the gate. Open: mon-fri 8-4:30; sat/sun 10-5. (Golden Gate Park)

Japanese Tea Garden - Golden Gate Park (off Tea Garden Drive), 752-4227

www.frp.org/japanese_tea_garden.asp

The peaceful winding paths, little bridges, and decorative structures that make up this ornamental garden were originally built for a world's fair around the turn of the century. Visit the authentic tea house where you can rest and sip delicious tea. It's a little known fact that fortune cookies were invented in this very tea house. (Local Chinese restaurants adopted them soon after.) The Tea Garden is an interesting place to visit, but it does cost $3.50 to get in. After 5:00 admission is free. Open: daily 8:30-6pm. (Golden Gate Park)

Other Golden Gate Gardens

Conservatory of Flowers

The Conservatory of Flowers, a Victorian-era glass building near the Stanyan Street entrance of the park, has an impressive aquatic plant display (tues-sun 9-4:30; 666-7001; admission $5). There's also a Tulip Garden, located next to the Dutch windmill at Ocean Beach. And at the Garden of Shakespeare's Flowers, you'll find plants and flowers mentioned in the bard's plays (at Martin Luther King, Jr. Dr. & Middle Drive E.).

beaches

Ocean Beach

One of the wonderful things about San Francisco is that there are excellent beaches within the city limits. Ocean Beach is at the west end of Golden Gate Park, and it's easy to get there by bike: just ride down John F Kennedy Drive and take a right at the bottom of the hill. You'll pass a windmill on the way. The beach is flat and sandy, and it's a favorite with local surfers. Bus 5 will take you right there, too. Or ride the MUNI N-Judah train to the end of the line. There's also a great cafe at Ocean Beach called Java Beach (see Sunset chapter).

Baker Beach

This one is much prettier than Ocean Beach because it has a view of the Golden Gate Bridge and the Marin Headlands. It's an amazing place to watch the fog roll in. There's a "clothing optional" section here (before the rocks, as you're going towards the bridge). If you go in the water, watch out for the rough surf and undertow. I once saw it knock a friend of mine right off his feet while he was just standing there! The Sunset bus 29 will take you to the parking lot above the beach. (Presidio)

China Beach

This is another beauty of a beach. It's located in the Sea Cliff area. Get a load of some of the mansions on your way in. MUNI 29 is the bus line that will take you closest to China Beach. If you're coming from the direction of Golden Gate Park, get off at Del Mar, before the bus makes a sharp right hand turn into the Presidio. Walk along 25th Street to Sea Cliff Ave and there you are. (Sea Cliff)

Fort Funston

This is a cool place to hang out and watch hang-gliders jump off the cliffs. It's located in the west of the city, off of Skyline Boulevard. To reach the beach, walk through the public parking lot and climb down one of the paths through the dunes. Take the MUNI "L" train to the zoo, and then change to bus 18. Or if you're more ambitious - ride a bike. It'll take you about 20 minutes from the bottom of Golden Gate Park. Just follow the path south from Ocean Beach next to the Great Highway. (Fort Funston, near Lake Merced)

Golden Gate Bridge Beach

Not surprisingly, you'll find this beach right next to the bridge, north of Baker Beach. Leave your bathing suit at home, but bring sun block: it's the best place for nude sunbathing. The area is very rocky and you'll have to climb down some fairly steep paths from the Presidio to reach the beach. It's a bit tricky, but very beautiful and worth the effort. Don't try climbing over the rocks from Baker Beach: it's really dangerous. MUNI lines 28 & 29 will take you there. (Presidio)

libraries

Main Library - 100 Larkin (at McAllister), 557-4400

www.sfpl.lib.ca.us

You need to be a member to borrow books, but this library is also a comfortable place to just hang out and read magazines and newspapers (5th floor), listen to CDs, or watch videos (ground floor; sign up at the info desk). The 3rd floor has novels (in many different languages). It's possible to surf the internet here (and at all branch libraries) for free, but it's always crowded and you may have to wait awhile for a terminal. Internet access computers are on every floor but the 2nd. You have to sign up at the desk on each floor. **Free wifi** access is available. There's a cafe on the ground floor that's not a bad place to take a break. They have decent sandwiches for about $5, as well as juices, coffee and tea. Or head across the street to the Gyro King (see Tenderloin chapter). The library hosts many free events, including film screenings. Open: mon 10-6; tues, wed, thurs 9-8; fri 12-6; sat 10-6; sun 12-5. (Civic Center)

Other San Fran Public Library branches include: Chinatown (1135 Powell St, 355-2888); Eureka Valley/Harvey Milk (3555 16th St, 355-5616); Mission (300 Bartlett St, at 24th, 355-3800); Park (1833 Page St, btwn Cole & Shrader, 355-5656); North Beach (2000 Mason, at Columbus, 355-5626). All of these branches offer **free wifi** service, except the North Beach branch.

tennis

There are well-maintained, free, public courts all over the city. Nice ones can be found in Dolores Park (see Parks, above), Buena Vista Park, and Alamo Square (see Awesome Views, above). In Golden Gate Park there are courts opposite the Conservatory of Flowers, but they

cost $4 on weekdays and $6 on weekends. Pay at the clubhouse. In the evenings and on weekends it's smart to reserve (call 753-7001). If you need a racquet, check the second-hand stores. Upstairs at Thrift Town (see Mission chapter) is a good place to start.

surfing

Looking to catch some rad wave action? Or just wanna watch? Ocean Beach is the place, dude. Surf's up anywhere from the Cliff House all the way down to Sloat Street by the zoo. Call 273-1618 to hear a surf report before you go. Be aware that the surf here can occasionally be very strong. Pacifica, a few miles south of the city on Route 1, is another destination for serious surfers. A bit farther south of Pacifica is Mavericks, located in Half Moon Bay. Mavericks is world-famous for its big wave surfing.

skateboarding

San Francisco may be the best city in the world for skateboarding. There are skaters all along the Embarcadero (EMB). Check out Pier 7 in particular, or buy a map for $3 at FTC (622 Shrader, btwn Haight & Waller; 626-0663) that'll tell you all the current hot spots, the best times to skate, *and* how to avoid cops.

juggling

SF School of Circus Arts - 755 Frederick St (at Arguello), 759-8123

www.circuscenter.org

All forms of circus arts are taught here, including: clowning, Chinese acrobatics, trapeze (workshops for beginners cost $38.50), and of course, juggling. Jugglers of all ages and skills are welcome to drop in on Sunday evenings from 7 to 10:00 (admission $4). It's a good way to meet some locals. Less coordinated visitors can sit upstairs in the bleachers and watch the classes in action. The school is located next to Golden Gate Park and a few blocks from Haight Street. (Sunset)

saunas & gyms

Kabuki Springs & Spa - Japantown Center, 1750 Geary Blvd (at Fillmore), 922-6000

www.kabukisprings.com

This traditional Japanese communal bath is a fantastic place to spend some hours rejuvenating. There's a hot and cold pool, a steam room and a dry sauna. It costs $16 during the week before 5pm; and $20 after 5pm and on weekends. That ain't cheap, but you do get to use all the complimentary bath products! There are separate days for men (mon, thurs, sat) and women (sun, wed, fri). Tuesdays are co-ed. Look for the entrance directly behind the Kabuki Theater. Open: daily 10am-9:45pm. (Japantown Center - see Other Districts chapter)

Osento - 955 Valencia St (btwn 20th & 21st), 282-6333

www.osento.com

Sorry guys, this one's for women only. The facility includes an indoor communal hot tub and an outdoor cold pool, and both wet and dry saunas. At night you can sometimes see stars from the patio. It's peaceful and clean in here and a great way to revitalize. Admission is sliding scale - from $12 to $20 - and is good for the entire day. Bring your own towel, or rent one for $1. Open: daily 1pm to 1am; last entry at 11pm. (Mission)

Embarcadero YMCA - 169 Steuart St (btwn Mission and Howard), 957-9622
www.ymcasf.org/Embarcadero

This fitness center is clean, well-maintained and, for the most part, attitude-free. You'll find a swimming pool, free weights, nautilus equipment, Stairmasters, and a host of other machines. There are also exercise classes of all sorts, from aerobics to yoga to kick boxing - and some are offered for free. Check their website or call for details. A day pass costs $15. Open: mon-fri 5:30-9:45; sat 8-7:45; sun 9-5:45. (South of Market)

cheap thrills

Glass elevators

Riding an elevator to the top floor of the Westin St Francis Hotel (355 Powell St on Union Square) is one thing. Riding it down is another. The hotel has 5 high-speed glass elevators that ride on the outside of the 31 story building. Just walk into the fancy lobby and you'll see the elevators towards the back. When you get to the top, check out the amazing view. Then hit the 'down' button and hold on to your lunch. (Union Square)

The Wave Organ

The mysterious sounds of the Wave Organ can be quite spooky. This "acoustic sculpture", located on a narrow jetty in the Marina District, was built by the clever people at the Exploratorium (see Museums chapter). The sounds emanate from pipes that emerge from the water through a stone terrace. You may want to bring a picnic and enjoy the view of the city as well as the organ "music". It's a perfect rest stop if you're biking along the perimeter of the Bay. From the Marina Green (btwn Aquatic Park & the Presidio), ride your bike along Marina Boulevard in the direction of the Presidio. Take a right on Baker Street (if you pass the entrance to the Exploratorium, you've gone too far); then follow the water and the street you're on will become Yacht Road. Continue to the very end of the jetty and look for the low rock terrace. (Marina)

Golden Gate Bridge

It takes about 30 minutes to walk across the most famous and beloved bridge in America, and it's the best way to fully appreciate its size and beauty. The views of the city and the bay from this angle are impressive, to say the least. But think twice if you're considering jumping: it takes four long seconds and you hit the water at 75 miles per hour. To get there take MUNI bus 28 from 19th Avenue. There's an official website at *www.goldengate.org* with interesting historical facts, and photos.

MUNI bus 33

I remember distinctly when I first visited San Francisco and was bussing from the Upper Haight to the Mission on the old number 33. It's quite a ride. When the bus crosses Market Street it makes an intense hairpin turn and there's an incredible view. That alone is worth the fare (see Getting Around chapter).

street festivals

San Francisco is a city that knows how to party, and there are street festivals going on here all year round. The following are just a few of the biggest and most popular. Check online or *The Guardian* and the *SF Weekly* (see Music Chapter) for specific dates.

Chinese New Year Parade & Festival - February

www.chineseparade.com

To celebrate Chinese New Year, dragon dancers and drummers with lanterns and firecrackers (to scare away evil spirits) parade from the Financial District to Chinatown. The parade usually starts at 5:30. It's an intensely crowded event, so stake out your viewing spot early. (Financial District to Chinatown)

Saint Stupid's Day Parade - April 1st

www.saintstupid.com

Every year on April Fools' Day a big parade with lots of crazy costumes winds its way through the financial district and ends up at the Pacific Stock Exchange (an appropriately stupid, capitalist institution). People do things like throw socks around in the name of the Pacific Sock Exchange. It's a big, stoopid party filled with lots of silliness. (Financial District)

Cherry Blossom Festival - mid April

This celebration of the blooming of the cherry blossoms takes place from 10 to 6:00 on two weekends in April. You'll find traditional Japanese music, crafts, food, and martial arts demos. There's also a colorful Grand Parade up Post Street one afternoon. For info call: 563-2313. (Japantown)

Cinco de Mayo - May 5th

www.cincodemayosf.com

This traditional Mexican festival, which celebrates an historic Mexican victory over the invading forces of the French, includes giant puppets, drumming, dancing and a really good vibe. To get in on the fun, head for Mission Street in the morning. For info call: 206-0577. (Mission)

Bay to Breakers - mid May

www.baytobreakers.com

This uniquely San Francisco marathon covers 7.5 miles across the city from the Financial District to Ocean Beach. If you think running that distance is hard enough, imagine doing it drunk and pulling a keg behind you while dressed as Elvis. Many of the participants in this race go all out with their costumes. You're also guaranteed to see a few who let it all hang out and run nude. Check the website for the exact route. (Financial District to Ocean Beach)

Carnaval - last weekend in May

www.carnavalsf.com

This is a huge multi-cultural festival that fills a weekend and culminates in a spectacular parade. Latin American and Caribbean cultures are highlighted, but many different traditions are represented in this diverse, vibrant street party. Thousands of people line the route in the Mission for the Grand Parade on Sunday morning where colorful costumes, enormous floats, and thong-clad butts abound. The festival area is usually along Harrison (btwn 16th & 23rd), where there are several stages, booths with traditional food, and stalls selling folk art. (Mission)

Pride Celebration & March - last weekend of June

www.sfpride.org; www.dykemarch.org

San Francisco is one of the most gay-friendly cities in the world and the whole month of June is filled with queer events. The Celebration culminates in a weekend-long party, capped by the Transgender March on Friday night, the Dyke March on Saturday afternoon, and the enormous Pride Parade on Sunday.

Blues Festival - end of September

www.sfblues.com

The Blues Festival is over 25 years old and kicks off every year with a free concert at Justin Herman Plaza. Tickets for other shows in the festival usually run about $20. (Embarcadero)

Folsom Street Fair - end of September

www.folsomstreetfair.com

In a festive finale to San Francisco's Leather Pride Week, the community puts its best cheek forward for the largest S/M and fetish event in the world. (South of Market)

Castro Street Fair - early October

www.castrostreetfair.org

A vanilla version of the Folsom Street Fair with less leather and more rainbows. Join the crowd at Castro and Market. (Castro)

In the Street Festival - October

www.luggagestoregallery.org

This two-day festival of street theater features all kinds of performances, from acrobatics and European-style clowning to funky spectacles you've probably never witnessed before. In the spirit of traditional street theater there's no admission charged for the festival and you won't find anything for sale. Cool. Check online or keep your eyes open for the schedule in one of the weeklies. The festival is held in Cohen Alley - in the 500 block of Ellis Street, between Hyde and Leavenworth. (Tenderloin)

Dia de los Muertos (Day of the Dead) - November 2nd

www.dayofthedeadsf.org

This is one of the most festive Mexican holidays. It's a time when the dead are honored with a big celebration. In the evening, crowds gather outside the Mission Cultural Center (Mission Street at 25th) for traditional food and a party. This is followed by a parade through the Mission where drummers and dancing skeletons abound. Bring candles and flowers for the community altar if you're so inclined. The whole event is free. (Mission)

Dia de los Muertos

The Mission

Home to the best taquerias outside Mexico; ground zero for trendy restaurants and boutiques; the district where San Francisco's alternative culture thrives: the Mission is all this and more. In spite of the high-speed gentrification brought on by the dot-com era, the district remains Latino. And it's still home to much of the alternative San Francisco culture created by the artists and activists who used to live here when rents in the district where cheap (a familiar story). Now the famous murals (see Museums chapter), the Central American food and music, the hip cafes, and the yuppie boutiques co-exist in the Mission in a strange and strangely heady mix. Valencia Street from 16th to 24th is filled with up-scale cafes, restaurants, bars and boutiques. Yet, on Mission Street, just one block parallel to Valencia, you'll find Latino and Asian-owned produce markets, cheap clothing, and knick-knack stores. Pick a sunny day and walk up 24th street, from Valencia to Potrero, and you'll experience what's called "the heart of the Mission".

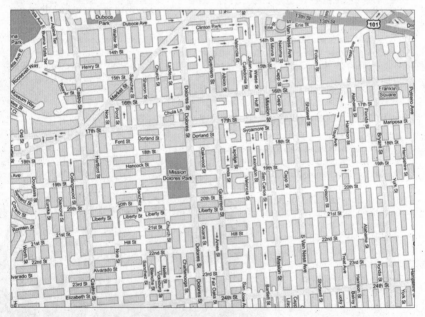

cafés in the mission

Philz Coffee - 3101 24th St (at Folsom), 282-9155

www.philzcoffee.com

You know the old phrase "best cup of coffee in town"? Well, this might honestly be it. They make each cup individually, grinding the beans and brewing a strong and delicious cuppa joe

Philz Coffee

that'll knock your socks off. They have a tantalizing selection of flavors, including my favorite, "Turkish coffee", which is creamy and rich and made with cardamom and mint. It's $2.50 a cup, which isn't cheap, but it's worth every penny. The coffee is gourmet quality, but Philz is a very unpretentious place and has a kicked-back atmosphere with floppy couches and a couple of tables with chess boards. The outdoor benches are surrounded by big green plants and it's a perfect place to sit on a sunny day and catch the 24th Street vibe. They also have a branch in the Castro at 3901 18th Street near Sanchez. Stop in and catch a buzz. Open: daily 6:30am-9pm.

Atlas Café - 3049 20th St (at Alabama), 648-1047

www.atlascafe.net

Delve deeper into the Mission district away from both Mission and Valencia Streets and you'll find great little neighborhood spots like this one. The Atlas is a meeting place for a diverse, local crowd. It's light, airy, and offers indoor and outdoor seating - including a cozy patio that's open all year. The menu is nutritious and delicious. It includes innovative sandwich combinations like their roasted yam with feta, and baked beets with kale. Expect to pay between $6 and $8 for a meal. Breakfast is served on weekdays until noon and weekends until 1pm. Your best bet is the steamed eggs on a bagel or croissant - hearty and satisfying. Live music of the blues-roots-and-Americana variety, happens every Thursday from 8 to 10pm and Saturday from 4 to 7pm. Check out the magazine rack for some good, free reading. Internet access, however, is not free. You'll need to buy a $5 pass at the counter, good for 24 hours of unlimited surfing. Open: mon-fri 6:30am-10pm; sat/sun 8-8.

Café Petra - 483 Guerrero St (btwn 16th & 17th), 240-3240

www.cafepetra.biz

This extremely cozy café is off the beaten path in the Mission and a nice escape from the hubbub of Valencia Street. A bamboo-covered ceiling and padded, colorful benches make for an attractive, comfortable space to lounge. Salads, sandwiches and breakfast foods are served, as well as coffee, tea and juices. There's **free wireless access** for laptops and two high-speed terminals in the back. There's also a nice collection of books to flip through. Open: daily 7am-11pm.

Dolores Park Café - 501 Dolores St (at 18th), 621-2936

www.doloresparkcafe.org

This is an ideal pre-and-post-Dolores-Park-event gathering place (see Hanging Out chapter). They serve a variety of hot and cold sandwiches ($5.95 to $7.50), as well as smoothies ($3.75), a limited breakfast menu and pastries. Every Friday is acoustic cabaret night, featuring musicians from the Bay Area and beyond. There's outdoor seating on Dolores Street. Inside, light floods through the big windows making it a great place to soak up the morning sun or to escape the encroaching afternoon fog. Open: daily 7am-8pm; fri (music nights) 'til 9:30.

Faye's Video - 3614 18th St (btwn Guerrero & Dolores), 522-0434

Here's another one near Dolores Park... Now, as a traveler you may not need to rent movies, but you will need coffee, and lots of it. There's no indoor seating here, but I love to sit on the sweet little bench out front and watch the local traffic. Faye brews up tasty coffee and you

won't have to deal with the crowds at Tartine (see below) across the street. And if you *do* want to rent a film, they have a good collection of contemporary and classic titles. Open: mon-thurs 7am-10:30pm; fri 7-11; sat/sun 8:30-10:30.

La Boheme - 3320 Mission St (at 24th), 643-0481

If you're interested in Latin American politics, be sure to visit this neighborhood café. It's been around for over 30 years is a popular meeting point for politically active Latinos. While you're there you might see a few of the people whose pictures dot the walls. Mismatched tables and chairs, a handwritten menu board, and the eclectic clientele, make for a warm, funky atmosphere. There are two computers with high speed internet access (pay at the counter) and **free wireless service** if you've got a laptop. Grab one of the corner tables if you want to plug in to the outlets that dangle down the wall. Open: daily 7:30am-10pm.

Café La Onda - 3159 16th St (btwn Valencia & Guerrero), 863-6517

This place is an oasis of serenity in the midst of busy 16th Street, with wooden tables and old comfy couches. There's a corner with books you can browse and the table in the back is filled with political flyers and notices of local events. It's a great place to curl up with a novel, or maybe write one. There's a bar with beer, wine, and sangria, and a variety of foods on the menu. They now offer **free wireless** service, too. Cool. Open: sun-sat 10-10; mon 1-10.

Muddy's Coffee House
1304 Valencia St (at 24th); 521 Valencia St (btwn 16th & 17th), 863-8006
262 Church St (btwn Market & 15th), 621-2233

The atmosphere at Muddy's is nothing to write home about - all three of these branches are sort of dark and dreary. But they do serve reliably strong coffee. There is free wireless service at the 24th Street branch, but at the other two, you'll need to buy a $5 card that gets you unlimited internet access for 24 hours. All three have computers available with a high speed connection that you can use for a fee. Open: mon-thurs 6am-11pm; fri 6am-midnight; sat 7am-midnight; sun 7am-11pm.

Café Que Tal -1005 Guererro (at 22nd), 282-8855

This is one of my favorite cafés in the Mission because it's slightly off the beaten path and because the staff are exceptionally friendly. It has tables that are big enough to work comfortably at with your laptop (**free wireless**) or to hang comfortably with a group of friends. It's also a cozy place to read - especially when the sun pours in through the front windows. In addition to all the usual coffee drinks there's a small selection of food, including: soups, sandwiches served with salad, bagels with spreads, and granola with yogurt and fresh fruit. Open: mon-fri 7am-7pm; sat/sun 8am-7pm.

eating in the mission

Bissap Baobab
2323 Mission St (at 19th), 826-9287; Little Baobab - 3388 19th St (at Mission), 643-3558

www.bissapbaobab.com

Senegalese. My favorite thing about this place is their cocktails, which are made from freshly squeezed juices and often infused with ginger. Try a tamarind whiskey or margarita. The food

is uniquely flavored and the fish dishes are very popular. There aren't a whole lot of vegetarian options, but what they have is tasty (try the *mafe* - vegetables, tofu and peanut sauce served on couscous - $8.25). The waiters are always friendly and there's a great laid-back atmosphere, even when it gets crowded (which it does on weekend nights). When you're done eating, step around the corner to Little Baobab and shake your booty to some world beats. Have another cocktail, while you're at it. Bissap Baobab open: tues-sun 6pm-10:30. Little Baobab open: mon-sat 6pm-2am.

Foreign Cinema - 2534 Mission St (btwn 21st & 22nd), 648-7600

www.foreigncinema.com

California/Mediterranean. It's more expensive than I would normally recommend ($10-$30 for dinner), but if you want to splurge, a night out here can be very interesting. Their patio is kind of like a fancy drive-in, with a little speaker at each table and films being projected against the cement wall of the courtyard. The film calendar changes weekly and includes American as well as foreign films by masters such as Fellini, Polanski and Godard. But don't expect everyone to sit quietly and watch the film. This is not a cinema, as the name suggests, but a restaurant. There's a big comfortable dining room too, but you can't see the films as well from there. If the dinner menu is out of your budget I suggest arriving late for a drink (when it's less crowded). The films begin at dusk. Open: mon-thurs 6pm-10pm; fri/sat 'til 11:30.

Radio Habana Social Club - 1109 Valencia St (near 22nd), 824-7659

Mostly Cuban. Where but San Francisco would you be served Cuban black beans and rice along side a main dish from India as if it were a completely unsurprising combination. The food in this little nook of a place is as eclectic as the decor. Every inch of wall space is covered in photographs and art work, the theme of which I've yet to decipher. The staff and clientele are just as colorful, and thankfully, the place isn't overrun with hipsters - yet. And I'm always happy to find somewhere with good sangria ($4.75 a glass). The plates of food are just the right size: you won't leave hungry, but you won't stuff yourself to the bursting point either. You can also order tapas and share with friends. To find the place, look for the toys and knick-knacks stuck all over the outside of the building. Open: mon-sat 7pm-midnight.

Herbivore - 983 Valencia (btwn 20th & 21st), 826-5657

www.herbivoresf.com

Vegan. I think the food here used to be better. I'm not sure what's changed, but it just doesn't do it for me like it used too. Still, if you're looking for vegan fare, you'll have a lot of options. I like the lentil loaf served with beet gravy. Try to save room for vegan chocolate cake. The restaurant is light and airy and there's a nice back garden. Breakfast is served from 9am to 2pm. Open: sun-thurs 9am-10pm; fri/sat 9am-11pm.

Valencia Pizza Pasta - 801 Valencia St (at 19th), 642-1882

Italian. This eatery is a great place to go for a big bowl of pasta with no attitude. They have good old fashioned comfort food: lasagna, ravioli, pizza, grilled fish, mashed potatoes, and garlic bread. Wine can be ordered by the glass or bottle. It's an intimate space, with tables close together and some booths that offer a little more privacy. It's a good place for breakfast as well. But be warned: it gets quite crowded, especially on the weekends. Open: mon-fri 11am-3pm; mon-sat 5pm-9:30pm; sat/sun 9am - 3pm.

Café Ethiopia - 878 Valencia St (btwn 19th & 20th), 285-2728

Ethiopian. The meals here are authentically Ethiopian: healthy portions of food are served on *injera*, a big sourdough pancake, and everyone eats with their hands from the same platter. It's a very tasty and inexpensive way to dine. The servings are enormous, and that's a good thing because you may be pretty hungry by the time it shows up: the service is leisurely. This is a quirky little place - in addition to the main restaurant, there's a lunch counter that serves coffee drinks and bagels. Open: daily 11:30am-3:30pm and 5:30pm-10:30pm.

Café Gratitude - 2400 Harrison St (at 20th), 824-4652

www.withthecurrent.com

Vegan/Organic/Live. Okay let me start off by saying that if you have a touch of the cynic in you, as I do, you may have a hard time swallowing the earnestness of this place. Each dish at Café Gratitude is named for a positive affirmation as in "I am Dazzling" (ceasar salad), "I am Sensational" (pesto pizza) or "I am Bright Eyed" (seasoned fruit porridge). Believe me, I have to have at least one cup of "I am Courageous" house coffee in me before I'm up to asking for any of these dishes. However, they use organic ingredients, support local farmers and sustainable agriculture and serve Fair Trade coffee and teas, so I support them. Also, the food is delicious, the waitstaff are pleasant, and the dining room is comfortable. The desserts and frozen nut milk ice cream are good enough to get me saying, "I am Delighted" over and over again. Open: mon-sat 9am-10pm; sunday 10am - 3pm.

St. Francis Soda Fountain - 2801 24th St (at York), 826-4200

Classic American food. This soda fountain was established in 1918. It was last remodeled in 1949 - and it feels like it. There's an authentic atmosphere in here that couldn't exist in any kitschy reproduction of an old diner. This is retro for real. The prices, however, are quite modern. They're fair, but not particularly cheap for no-frills food like grilled cheese, burgers, and ham sandwiches. But everything is made from scratch, including the ice cream, and it all tastes like it's supposed to. Nothing is too fancy. Have a seat at the long counter and see if you can get through a whole ice cream Sunday. Open: daily 8am-9pm.

La Victoria - 24th St & Alabama (look for the "homemade tamales" sign)

Starch. *Pan dulce*, or Mexican sweet bread, is sold all over the Mission. They're often not quite as sweet as they look, which is actually why I like them, but they're always cheap and you can usually pick up a whole bag of them for a couple of dollars. This particular place has a superior selection of pan dulce. Grab a metal tray and some tongs and then pick out the ones that you want. There are also fresh *tamales* on the counter. Open: daily 7-7.

Sunflower - 506 Valencia St (at 16th); and 3111 16th St (btwn Mission & Guerrero), 626-5022

www.sunflower-restaurant.com

Vietnamese. This restaurant has two separate dining rooms. The one on Valencia is much bigger and you're more likely to find seating, but the smaller one around the corner is cozier. They share the same kitchen, so either way you'll be enjoying their exceptionally fresh food. Try the big bowl of vegetarian noodle soup with basil, served with bean sprouts on the side ($6.95). Open: mon-thurs 11:30am-10:30pm; fri 10:30am-11:30pm; sat noon-11:30; sun noon-10:30.

Tartine - 600 Guerrero St (at 18th), 487-2600

www.tartinebakery.com

Baked. Follow your nose to this amazing bakery, then give in to the call of the wild eclair and

indulge your chocolate fantasies. Almost everything in here is made with organic ingredients, and although their desserts are a bit extravagant and not at all cheap, it's the kind of thing you need to treat yourself to now and then. Their cheesy sandwiches are intense, filling, and almost too rich for me. They also bake hearty loaves of bread, which are available after 4pm from Wednesday to Sunday. Open: mon 8am-7pm; tues/wed 7:30am-7pm; thurs/fri 7:30am-8pm; sat 8-8; sun 9-8.

Pakwan Pakistani Indian - 3180 16th St (btwn Guerrero & Valencia), 255-2440

Indian/Pakistani. This is no-frills dining at its best. Help yourself to silverware, carafes of water and condiments. They don't serve alcohol, but it's okay to bring in your own booze (the K & D market across the street sells beer and wine). The food is a little bit greasy, but very palatable, and at $6 to $8 dollars per plate, a good deal. Open: daily 11:30am-11pm.

Bombay Bazaar - 548 Valencia St (btwn 16th & 17th), 621 1717

Indian. This place serves "*chaat*", or Indian fast food. For around $3 ,you can get saffron rice, samosas, puri and your choice of vegetable. There are only two little tables in here, so I usually take my lunch to nearby Duboce Park (see Hanging Out chapter). For dessert, they offer Indian ice cream, with flavors like mango, lychee and saffron rose. Next door is an Indian grocery store that sells spices and rice in bulk, Indian condiments, postcards and posters. Open: sun thurs 11 10; fri & sat 11 11. (Mission)

Papalote - 3409 24th St (btwn Valencia & Guerrero), 970-8815

www.papalote-sf.com

Organic Mexican. With items like vegan chorizo on the menu, this taqueria is definitely not typically Mexican. But I have to admit, this place has almost spoiled the other taquerias for me, because once you have a Papalote's fish taco and some of their home-made salsa, every other place pales in comparison. It's the high-quality ingredients they use: super-fresh and organic. And then there's the "soyrizo", a truly tasty vegan alternative to chorizo, the traditional, spicy Mexican sausage. The service isn't speedy, but it's well worth the wait. Open: mon-sat 11am-10pm; sun 11am-9pm.

Suriya Thai Restaurant - 1432 Valencia St (btwn 25th & 26th), 824-6655

Thai. Honestly, I think this is the best Thai food I've ever had in my life. I've tried many different dishes and have never, ever been disappointed. And everything is presented beautifully, so the food looks as good as it tastes. Unfortunately, the prices went up recently, which makes it a little more expensive than I'm used to paying, but the portions are enormous and I always leave with tasty left-overs. Help! I've fallen in love with the Evil Jungle Prince (spinach and tofu in coconut milk with spicy peanut sauce - $11.95). Open: tues-sun 5pm-10pm.

Emmy's Spaghetti Shack - 18 Virginia St (at Mission), 206-2086

Italian. If it wasn't for the brightly colored mural on the outside, you might think this place was a dumpy little hole-in-the-wall. It is sort of dark and grotto-like in here. However, the food is good (though not particularly cheap) and the decor, on second look, is a comfortable jumble of styles. For some reason, there are lots of little aprons hanging from the ceiling. They serve all kinds of pasta dishes, from spaghetti and meatballs ($8) to roasted butternut squash risotto ($11; highly recommended). The portions are huge and you're guaranteed to leave satisfied. Show up very early for dinner, or you'll have to wait for a seat. Open: sun-thur 5:30pm-11pm; fri/sat 'til midnight.

El Zocalo - 3230 Mission St (btwn Virginia Ave & Fair Ave, 4 below Cesar Chavez), 282-2572

El Salvadoran. If you've never tried *papusas* (soft corn tortillas stuffed with melted cheese and beans or meat) this would be the perfect place to sample some. They're well known for their fish dishes, too. It's a particularly clean and friendly place. Service tends to be a bit slow, but be patient: the nice ladies who work here are making fresh tortillas by hand for you. Open: daily 11am-3am.

Mitchell's Ice Cream - 688 San Jose St (at 29th), 648-2300

www.mitchellsicecream.com

Ice cream. This famous little place has been family-owned since the 1950s, and they crank out some seriously tasty homemade ice cream in a wide variety of flavors. There are all of the traditional ones, and then there are the downright weird flavors, like avocado and ube (purple yam). Personally, I'm really into the buko (baby coconut), though the Mexican chocolate (with cinnamon) and the mango are always tempting. They make flavors to suit many holidays, and if you're around from late October to early February, see if they have any of their pumpkin ice cream. Be adventurous and you're likely to be pleasantly surprised. You can also get Mitchell's ice cream at some cafés - look for their sign. Open: daily 11-11.

book & music shopping

Abandoned Planet Bookstore - 518 Valencia St (btwn 16th & 17th), 861-4695

The two cats that sleep in the window here are perfect mascots for this very mellow secondhand bookstore. Comfy chairs invite you to kick back and peruse the books before purchasing. The prices are generally low and I always seem to find something in here I've been wanting, at a price I can't refuse. Have a look at the tiny art gallery tucked away in the back, too. Open: mon-thurs 4-9; fri/sat 1-11; sun 1-9.

Adobe Books - 3166 16th St (btwn Valencia & Guerrero), 864-3936

www.adobebooks.org

Not too long ago a local artist, Chris Cobb, created an installation here by organizing all the store's books according to color. It was a beautiful thing - slightly inconvenient, but impressive. Normally, however, their varied collection of reasonably priced books is fairly well organized, and I can pretty much guarantee that you'll walk out with a good read. Hang out in their comfy chairs, check out the art gallery in the back, or browse for a while. Adobe Books is a neighborhood institution - a social hub for artists and musicians in the Mission. Occasionally, they host live music events. Open: daily 10-10.

Al's Comics - 491 Guerrero St (btwn 16th & 17th), 861-1220

www.alscomicssf.com

Comic freaks take note: this small shop is packed tight with a huge variety of large and small press comics and graphic novels. One section is devoted to the incredible amount of new stuff that arrives each week (check after 1pm on wed). Al also sells cards, toys and other collectibles. By the way, if you're in San Francisco in April, be sure to look out for the Alternative Press Expo (*www.comic-con.org/ape*), a giant exhibition hall full of comic books, mini-comics, zines and the artists who create them. Al's is open: mon-sat 11-7; wed 12-8; sun 12-6.

Borderlands Books - 866 Valencia St (at 19th), 824-8203

www.borderlands-books.com

If you're a fan of sci-fi, horror and fantasy, then this place is for you. They sell both new and used books in these genres. There's a reading area at the back with some seats and a cozy couch - a nice touch. Open: daily 12-8.

Dog Eared Books - 900 Valencia St (at 20th), 282-1901

www.dogearedbooks.com

I can lose myself for hours in this well-stocked second-hand bookstore. In addition to fiction and non-fiction books of all sorts, they sell used CDs and tapes; magazines and zines; and graphic novels and comics. They also have the most irresistible assortment of discounted remainders that I've ever seen - which has done much to beef up my personal collection of coffee table books. Open: mon-sat 11-8; sun 12-6.

Modern Times - 888 Valencia St (btwn 19th & 20th), 282-9246

www.moderntimesbookstore.com

This collectively-owned-and-operated bookstore has been a neighborhood institution since the 1970s. They stock books about progressive political thinking, social thought, cultural theory, globalization, and critical thinking; and there's also a small fiction section and a large collection of texts in Spanish. Add that to their children's books, graphic novels and fanzines, and you've got one excellent bookstore! Open: mon-sat 10am-9pm; sun 11am-6pm.

Socialist Action Bookstore - 298 Valencia St (at 14th), 255-1080

www.socialistaction.org

A socialist party, a publishing house, and a bookstore all share this building. The book collection is strong in cultural studies and social theory, as well as fiction. Everything is reasonably priced. Forums on labor issues and civil liberties are hosted here. Stop by to find out what's *really* going on. Open: mon-fri 10-6. (Mission)

Valencia St Books - 569 Valencia (btwn 16th & 17th), 552-7200

www.valenciastreetbooks.com

There's actually not a huge selection of books in here for such a large, airy space - but what they have is well chosen. There are some chairs and a couch in the sunny, pleasant front of the store. Keep an eye out for the strange, shorthaired Kitty named Grumble who lives here. Open: daily 12-9.

Aquarius Records - 1055 Valencia St (btwn 21st & 22nd), 647-2272

www.aquariusrecords.org

The "staff favorites" display at this, the oldest independent record store in the city, includes descriptions of the recordings that will make you want to hear them all. To do just that, head over to the great listening station in the back. The stock here (new and used; CD and vinyl) is consistently interesting and well-chosen. This is also a good spot to pick up flyers for shows. Open: mon-wed 10-9; thurs-sun 10-10.

Record Collector - 485 14th St (btwn Guerrero & Dolores), 864-4243

www.recordcollectorinc.com

Lots of musicians hang at this record shop, cuz the space is shared with a CD manufacturer

and a screen printing company that works with a lot of local bands. The collection of new-and-used CDs and LPs on sale here is interesting and varied. It's not the place to come looking for dance music or top 40 artists, but they've got something in just about every other category. Sometimes they sponsor shows in conjunction with their neighbors, Needles & Pens (see below). Open: daily noon-7pm.

other shopping in the mission

Needles & Pens - 483 14th St (btwn Guerrero & Dolores), 255-1534
www.needles-pens.com

This funky little DIY shop is located on a cozy little block of otherwise gritty 14th Street. It's definitely worth checking out for their collection of locally made t-shirts and handicrafts. There's also an interesting assortment of zines, by both well-known and as-yet-unknown artists. Have a peek in the back room; there's usually an art show going on. Last time I was there, there was a very cool tree house above the counter and I'm always curious to see what they come up with next. Open: thurs-sun 12-7; mon-wed intermittently (you might want to call first).

Otsu - 3253 16th St (btwn Guerrero & Dolores), 255-7900
www.heyotsu.com

This is a vegan boutique. That means that everything sold in here is completely free of animal products. They have some spiffy shoes and belts as well as cute t-shirts and sweatshirts. There's also an assortment of vegan cookbooks - for inspiration. Open: tues-sun 11-7.

Botanica Yoruba - 998 Valencia St (at 21st), 826-4967
www.geocities.com/botanicayoruba

Having trouble attracting a certain person or wealth into your life? Maybe you need to try some of the oils and candles they sell here for those purposes. They also sell incense, herbs and charms. If you have any specific spiritual needs, ask the people behind the counter. Open: mon-sat 10-6.

Casa Bonampak - 3331 24th St (at Mission), 642-4079
www.casabonampak.com

This colorful shop is a cool place to pick up presents for the folks back home. They specialize in Latin American imports from socially responsible vendors. All of their wares are handcrafted and the people who made them enjoy decent wages and working conditions. There are many beautiful things in here and they're a great business to support. You can also order their products online. Open: mon-sat 11-7.

826 Valencia - 826 Valencia (btwn 19th & 20th), 642-5905
www.826valencia.org/store

Arrgh me hearties! Drop anchor in this port to pick up pirate paraphernalia. Glass eyes and eye patches, message bottles, quill pens and other pirating supplies are found here. Test your skill at tossing a swab (mop) into a wooden crate suspended from the ceiling, or gaze with your one good eye into the briny fish tank. The creative displays change frequently here. And all the doubloons stolen from you rascals will go to support the writing program for kids that's held in a back room of the shop. Open: daily 12-6.

Clothes Contact - 473 Valencia St (btwn 15th & 16th), 621-3212

Hipster clothes and regular duds are sold here for $8 per pound, and for only $4 a pound on Tuesdays. Be careful, though, it adds up quicker than you might think. The punk music blaring throughout the store adds an interesting dimension to this shopping experience. If you happen to be in town for Halloween, this is an ideal place to pick up a cheap costume. Open: mon-sat 11-7; sun 12-6.

Community Thrift - 623 Valencia St (near 17th), 861-4910

www.communitythrift.bravehost.com

I've taken many out-of-town guests to this thrift store and they're always impressed. It's very well organized, which is kind of an amazing feat, considering they have a little bit of everything for sale. The profits benefit local charities. Donations are accepted at the side door from 10 to 5:00. Open: daily 10-6.

Retro Fit - 910 Valencia (at 20th), 550-1530

Vintage clothing, sunglasses, shoes and some furniture fill up this small space. Mahogany cabinets on one side of the shop overflow with theatrical make-up, wigs, fake beards and moustaches, and give the place an old-time-general-store feel. On the other side you can get a t-shirt with an iron-on transfer of you favorite rock band. It's one of the better vintage clothing boutiques on the Valencia Street corridor. Open: wed-mon 12-7.

Thrift Town - 2101 Mission St (at 17th), 861-1132

www.thrifttown.com

Thrift store afficionados will love this shop's two floors full of stuff. Everything's very well organized here and you're unlikely to go away empty-handed. Open: mon-fri 9-8; sat 10-7; sun 11-6.

The Scarlet Sage Herb Co. - 1173 Valencia St (near 23rd), 821-0997

www.scarletsageherb.com

Homeopathic remedies, aroma therapy supplies, and flower essences; in tablets, tinctures, or dried: whatever you need for your alternative health care regime, they've probably got it here. They also stock a wide variety of organic body care products. And in the back of the store you'll find reference books and remedies for treating pets. The people who work here are full of information and advice on how to heal yourself. Or, if you're interested in exploring alternative healing in depth, lectures by practitioners are held in the store as well. Open: daily 11-6:30.

Sacred Rose Tattoo - 491 Guerrero St (btwn 16th & 17th), 552-5778

www.sacredrosetattoo.com

The motto of this tattoo parlor - "friendly, efficient, artistic" - aptly describes the nature of the service you'll get here. It's a very comfortable environment and the artists will put you at ease, whether or not you're already covered in ink. They'll do custom work, or you can choose from the many designs displayed on the walls. They pride themselves on their sterile environment and the fancy stainless steel floor really does shine. Open: daily 12-7.

Body Manipulations - 3234 16th St (btwn Dolores & Guerrero), 621-0408

www.bodym.com

Body piercing, branding and scarification: you can get it all done here in a very professional, clean, and safe environment. This place was the first of it's kind in San Francisco, so they have lots of experience with every kind of body art. The staff are very friendly and will happily

answer all your questions. For branding and cutting you'll need a consultation first, but for a tattoo or piercing, walk-ins are welcome. Call or check their site for prices. Open: sun-wed noon-7pm; thurs-sat noon-8pm.

mission bars

Hush Hush Lounge - 496 14th St (at Guerrero), 241-9944

www.hushhushlounge.com

Shhhh. There's no sign on the outside of this bar. Look for the blue awning. Inside you'll find vinyl booths and an unpretentious atmosphere. People come to party and dance here while different DJs spin a variety of styles from hip hop and soul to pop and rock. The drinks are cheap but effective. Open: sun, mon, wed 6pm-2am; tues 7pm-2am.

La Rondalla - 901 Valencia St (at 20th), 647-7474

My friend lives across the street from this bar and is often kept awake by the Mariachi bands. And I once had the worst plate of cheese-whizzed nachos there that I've ever had in my life. My advice is to skip the culinary experience and just go to hang out in the tinsel and glitter with a $10 pitcher of margaritas and the lifer waitresses. This place is a Mission classic. Open: sun-thurs 5pm-midnight; fri 5pm-3am.

500 Club - 500 Guerrero St (at 17th), 861-2500

This joint has the divey feel of an old-man bar and ugly, fake wood paneling. But it does offer cheap happy hour drinks every day from 2 'til 7:00. To find the place, look for their landmark sign - a neon martini glass. In the summer, on Sunday afternoons, they often fire up a bar-beque. Open: mon-fri 3pm-2am; sat/sun noon-2am.

Dalva - 3121 16th St (at Albion), 252-7740

www.dalva.com

Dalva makes excellent sangria and has a great jukebox. It's a major party spot on weekends, so expect big crowds then. Other times, it's dimly lit and has an intimate feel: a good place to rendezvous with a friend. Open: daily 4pm-2am.

Doc's Clock - 2575 Mission St (btwn 21st & 22nd), 824-3627

www.docsclock.com

Seek out the beautiful neon sign that lets you know it's "cocktail time", and you'll find Doc's - a very laid-back, low-key bar. It's a cozy, neighborhood place that's great for conversation and - for those so inclined - a game of shuffleboard. Get there quick before it's overrun by suburbanites. Happy hour is from 6 to 9:00. Open: mon-sat 6pm-2am; sun 6pm-midnight.

The Lexington Club - 3464 19th St (at Lexington), 863-2052

www.lexingtonclub.com

This is one of the only neighborhood dyke bars in town and on weekends it's packed with cute, chic lesbians. During the week it's not as busy and is an ideal place to chat with a friend over a beer. The jukebox is very cool and has everything from The Stooges and Black Sabbath to Blondie, Dolly Parton, and TLC. There are also interesting touches to the decor: check out the snake toilet-paper dispensers! They offer an 'all you can drink' special on Thursday from 6 to 8:00 ($10 - no shots, though) and that's a fun time to knock back a few with the girls. Open: mon-thurs 5pm-2am; fri/sat 3pm-2am.

Elixir - 3200 16th St (at Guerrero), 552-1633

www.elixirsf.com

There is an enormous selection of beer on offer at this bar, as well as ciders and spirits. If you can't decide what to order, ask the advice of the friendly and knowledgeable bartenders. There's a rowdy party atmosphere here on Friday and Saturday nights. It's a mellow drinking spot the rest of the time. Open: daily 2pm-2am.

Latin America Club - 3286 22nd St (btwn Mission & Valencia), 647-2732

I love the laid-back vibe at this bar. Of course, it's more crowded and gets a party atmosphere on the weekends, but during the week it's a chill place to hang and maybe shoot some pool. The best seats are the ones by the front windows - or try to cram all your friends onto the little stage at the back. Open: sun-thurs 6pm-2am; fri/sat 5pm-2am.

The Lone Palm - 3394 22nd St (at Guerrero), 648-0109

www.lonepalmbar.com

Funky Art-Deco decor and white tablecloths makes this an unusual drinking spot in the Mission. A swanky 1920's speakeasy comes to mind, though perhaps a bit worn out at the edges. It would be an ideal place to sip a Cosmopolitan while wearing a cocktail dress, but don't let that stop you if it's not your style: anything goes. Open: mon-sat 4pm-2am; sun 6pm-2am.

The Make-Out Room - 3225 22nd St (btwn Mission & Valencia), 647-2888

www.makeoutroom.com

Why the hell is this place called The Make-Out Room? I dunno. But it's a good place to see live music or go dancing. The crowds, like the events, are eclectic. Local and touring rock bands are showcased here as well as various cabaret-style comedy acts and DJs spinning reggae, soul, funk and electronica. Most evenings admission is $6. Open: daily 6pm-2am.

The Phone Booth - 1398 South Van Ness (at 25th), 648-4683

This bar used to be one of my favorite neighborhood watering holes, until it became overrun with young scenesters. But if you show up early enough to get a table, or avoid the weekends, you can still take advantage of the cheap beer and authentic dive atmosphere. Open: sun-fri noon-2am; sat 1pm-2am.

Uptown - 200 Capp St (at 17th), 861-8231

In spite of its name, the Uptown is an unassuming little bar. There's a cosy corner with couches, two pool tables, candles, good music and a friendly crowd. Check out the drink specials. Open: daily 4pm-2am.

Zeitgeist - 199 Valencia St (btwn 14th & Duboce), 255-7505

www.zeitgeist.citysearch.com

The patio behind the Zeitgeist is an excellent place to sit on the rare warm night you might experience in San Francisco. Get an authentic dose of the Mission vibe while drinking a pint at one of the long picnic tables. This is often a gathering spot for bicyclists after Critical Mass (see Getting Around chapter), or for activists after other political events. It's a bike-friendly venue and there's no need to park outside: wheel it through the bar and leave it with the pile of others at the back. There are also rooms for rent here above the bar - for just $30 a night - but I've never met anyone who's stayed in one. You'll have to check that out yourself. Open: daily 9am-2am.

The Castro

While the Castro remains a sort of gay Mecca for those persecuted throughout most of the US, in some ways it looks and feels more like a gay Disneyland for affluent men. The transformation of the area, that used to be called Eureka Valley, began in the '50s and '60s when its working-class residents started to migrate to the suburbs. Gay men and women, who were becoming increasingly politicized (as they were increasingly persecuted), gradually took over the faded Victorian houses - and the Castro was born. Many people who consider this neighborhood their base remain socially committed and politically active, of course, but many more just like to party and enjoy the gay esthetic of the place. Whatever camp you fall into, you probably won't be disappointed by your visit to the Castro.

eating & drinking in the castro

Café Flore - 2298 Market St (at Noe), 621-8579

www.cafeflore.com

Situated at one of the district's busiest intersections (Market & Noe), this café is one of the most popular hang-outs in the Castro. The enclosed outdoor patio, surrounded by plants and flowers, is a lovely place to lounge on a nice day. The interior is made of wood and is very cozy, reminiscent of a ski chalet. Once known as "café hairdo" in reference to the stylish coifs of the customers, it can still be very sceney and cruisy here. Don't be surprised if the guy reading across from you is actually peering over an upside down book. On Sunday afternoons DJs take over the space for a club called Floored - amping the mood up a few notches. The scene is the attraction, but coffee drinks, a full bar, and moderately priced food are also available. The kitchen closes at 10:00. Open: sun-thurs 7am-11pm; fri/sat 7am-midnight.

Samovar Tea Lounge - 498 Sanchez St (at 18th), 626-4700

www.samovartea.com

In a town that wears its coffee loving on it's sleeve, Samovar Tea Lounge is a tip of the hat to all those who favor tea. Just read the menu of over 100 whole-leaf teas and herbal infusions, and the hectic pace of city life will seem to slow right down. This tranquil lounge also serves a variety of globally- and seasonally-inspired sweets and savories. And if you're a true tea aficionado, ask about the lectures and tea tasting events that Samovar hosts. Open: sun-thurs 10am-10:30pm; fri/sat 10am-11pm.

Spikes Coffee & Tea - 4117 19th St (btwn Castro & Collingwood) - 626-5573
www.spikescoffee.com

It's just a half block from the craziness of Castro Street, yet Spikes feels like a small-town neighborhood cafe. Lot's of regulars frequent this place and the sidewalk seating area is very chatty and friendly. Gourmet coffee and teas can be bought by the cup or pound. And the baristas here are pretty damn cute. Open: mon-sat 6:30am-7pm; sun 7:30am-7pm.

Three Dollar Bill Cafe - 1800 Market St (btwn Laguna & Octavia), 235-4821
www.threedollarbill.com

The Three Dollar Bill Cafe may be located in the Lesbian, Bisexual, Gay, Transgender (LBGT) Center, but everyone is welcome. This place serves up cafe culture of both the old and new school variety: there's **free wireless internet** service for networking individuals, but also space and encouragement for the community to gather. A variety of cultural events, including open-mic nights, a Radical Fairie coffee klatch, book and knitting groups, and art openings are hosted here. The staff are very friendly. Breakfast, lunch and light dinners are served, and there's also a full espresso bar, beer, and wine. Open: mon-fri 7am-10pm; sat 9am-10pm.

Cove Cafe - 434 Castro (btwn Market & 18th), 626-0462

There is nothing fancy about the Cove Cafe and that's why I like it: no Pinot Grigio, no olive tapenade. The Cove serves up simple breakfasts, lunches and dinners - sandwiches, fries, eggs, ranch dressing - you know the deal. It's as close to a diner as you'll get in the Castro. Open: daily 8am-9:30pm.

La Fajita Grill - 2312 Market St (btwn 16th & Castro), 593-0031

For fresh and tasty Mexican food in the Castro, try this little eatery. There's a small seating area inside, and some on the sidewalk out front. A burrito is slightly more expensive than one from the Mission, but still affordable at $6 to $8. And they grill their burritos, which makes them quite delicious at any time of day, but especially late at night after a few drinks. Open: sun-wed 11am-10pm; thurs-sat 11am-2am.

Moby Dick - 4049 18th St (at Hartford), 861-1199
www.mobydicksf.com

Well, gays certainly know how to work a literary reference. Moby Dick is an unassuming neighborhood bar with a pub-like ambiance: friendly bartenders, bench seating along the walls, a big wood bar, a pool table and video games in the back. When it gets busy on weekend nights and during happy hour you could get lucky and meet your Captain Ahab, but generally it's a mellow place to sit and drink with friends. Men definitely outnumber women here, though everyone is welcome. Open: mon-fri 2pm-2am; sat/sun 12-2am.

Orbit Room Cafe - 1900 Market St (at Laguna), 252-9525

A mod-looking Vespa crowd often frequents this spacious, stylish place. It's fun to sip cocktails at the curvy bar (where you might just witness the talented bartender, Alberta, invent a tasty new drink). Or grab an outside seat for optimal people-watching. Don't forget your shades. Open: mon-thurs 7:30am-1am; fri/sat 8-2; sun 8-midnight.

Twin Peaks Tavern - 401 Castro St (at Market), 864-9470
www.twinpeakstavern.com

Rumor has it that this was the first gay bar in San Francisco with windows through which pedestrians could see inside. The interior is that of a traditional gentlemen's bar - dark wood

panelling, mirrors, Tiffany lamps, and Irish coffee on the menu. The regulars here have been regulars for ages, so it's an older crowd that you'll find. Unfortunately, age-ism is alive in well in the Castro, so many youngsters miss out on getting to know their village elders by avoiding this historic bar. Twin Peaks is located right at the crossroads of the Castro, at Castro and Market Street. Open: mon-wed noon-2am; thurs-sun 8am-2am.

miscellaneous castro stuff

A Different Light Bookstore - 489 Castro St (btwn Market & 18th Street), 431-0891
www.adlbooks.com

This is no longer the community bookstore it once was, but it is the only bookstore left in the Castro that caters specifically to the Lesbian, Gay, Bisexual and Transgender community and it's still a decent place to pick up some gay lit, a nude coffee table book, magazines, or a bio of your favorite showbiz diva. They also stock international newspapers, zines, cards, posters and porno. Open: daily 10am-11pm.

Cliffs Variety - 479 Castro St (btwn Market & 18th), 431-5365

In spite of the fact that this classic family-run hardware store has been revamped to accommodate the changing demographic of the neighborhood - you'll find feather boas and wigs along side the nuts and bolts - Cliffs still feels like an old-time general store. Stop in if you're looking for accessories for your Halloween costume or a small toy gift. Open: mon-sat 9:30am-8pm; sun 11am-5pm

Halloween Castro Street - last weekend in October
www.halloweeninthecastro.com

This huge, infamous street party has gone through many incarnations over the years: from joyous neighborhood celebration; to drunken, violent, near-riot; to regulated chaos. I find it pretty awful, but every year up to 250,000 revelers turn up. At present it's an alcohol-free event with several stages, a costume contest, and a strong police presence. There's a suggested donation of $5 to help cover costs.

Chinatown

Chinatown gate

San Francisco's famous Chinatown Gateway at Grant Avenue and Bush Street, is a portal to one of the most densely populated neighborhoods in the US. Grant, the oldest street in the city, is filled with kitschy shops selling every kind of knick knack imaginable. Though interesting, keep in mind that this part of Chinatown was created for tourists. To see the parts of it that belong to the people

who actually live there, you need to explore the many side streets off of Grant. There are live animal and produce markets on Stockton Street, between Columbus and Broadway, that are especially crowded on Saturdays.

eating, drinking & shopping

House of Nanking - 919 Kearny St (at Jackson), 421 1429

This is a tiny, little restaurant with surly service and a lousy choice of drinks. Yet people line up out the door to wait for their turn to eat. Try the fried tofu with peanut sauce and you'll know why. Open: mon sat 11 10; sat 12 10; sun 12 9:30.

Imperial Tea Court - 1411 Powell St (near Broadway), 788 6080

www.imperialtea.com

They take tea very seriously here. From how it's grown and stored to it's preparation and consumption, these are the experts. Tastefully decorated in the style of a traditional Chinese teahouse, the pretty, sedate interior is perfect for trying one or more of the dozens of teas on offer. Chinese sweet and savory snacks are also available. Daily tea tastings start as low as $3 per person and up to $50 per person for "the full treatment". It's a peaceful place to learn about and appreciate many different types of tea. Tea paraphernalia is also sold here. Open: wed mon 11am 6:30pm.

Lucky Creation - 854 Washington St (at Ross Alley), 989 0818

Vegans take note: *everything* they serve in this Chinese restaurant is meat, dairy, and egg free. They do a lot of creative things with gluton (a meat substitute) and sometimes you'd swear that was chicken in your stir fry. It's a tiny, low key, no frills kind of place, but what it lacks in atmosphere it makes up for with its low prices and huge menu. Their popular weekend dim sum includes imitation pork buns. Open: thurs tues 11am 9:30pm.

Sam Woh - 813 Washington St (btwn Grant & Waverly), 982 0596

This restaurant has been run by the same family for over 30 years, and the low stools, wobbly tables and cracked floors look like they've been here just as long. Walk through the tiny kitchen and up the staircase in the back. I recommend heading all the way up to the top to eat: it's the least cramped of the three floors. Service can be a little slow, and the food is nothing to rave about, but at around $5 a plate for rice or noodles, it's a good deal. And a visit to Sam Woh's is sort of a classic San Francisco Chinatown experience especially after a night out drinking. Open: mon sat 11am 3am; sun 11am 9:30pm.

Clarion Music Center - 816 Sacramento St (at Waverly Place), 391 1317

www.clarionmusic.com

Everything sold here shakes, rattles, rolls or plays beautiful melodies from around the world. You'll find unique, handmade instruments at very reasonable prices including many small items that would make good gifts. They also sell CDs of music from around the world, and method books to teach you how to play. Open: mon fri 11 6; sat 9 5.

Buddha Lounge - 901 Grant (at Washington), 362 1792

Any self respecting pub crawl through Chinatown would have to stop here, if only for the pink neon Buddha sign. Upon entering you'll notice a sort of beach theme going on. What's up

with that? It's a small space, so be prepared to get to know your drinking neighbors at the bar. Open: daily 11am 2am.

Li Po's Lounge - 916 Grant St (btwn Washington & Jackson), 982 0072

An interesting mix of drinkers gather here, from Mission scenesters to older Asian men playing dice. You'll find a long curved bar and several dimly lit booths. I've never been to one of their karaoke nights, but I can imagine it would be a memorable experience. You can't miss the cave like entry way. Open: daily 2pm 2am.

North Beach

Thanks to the Italian immigrants who settled here during the gold rush, North Beach has a European feel to it and is known as the 'Little Italy' of the west coast. They left a legacy of excellent food served in restaurants decorated with red checkered table-cloths and paintings of the old country. Nowadays, the eating options range from chic and expensive meals to cheap and yummy slabs of pizza. I've listed a few of my favorites that are both reliable and affordable.

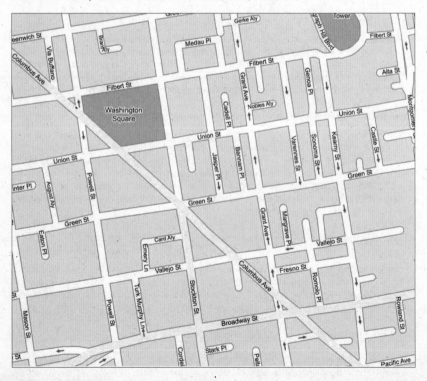

In the 1950s, North Beach was the hang-out of the Beatniks, and many famous artists and literary figures lived here. Every fan of Beat literature makes a pilgrimage to City Lights Books (see below) and Jack Kerouac Alley. I can think of few more perfect ways to spend a day than wandering from café to bookstore to restaurant to bar in North Beach.

If you're here in mid-June, check out the North Beach Festival (*www.northbeachfestival.com*) in Washington Square Park. It's a celebration of the Italian and Beat history of North Beach, and it's the oldest urban street fair in America. You'll be humming Sinatra tunes for a week. And if you're around at the end of July, try to catch some of the North Beach Jazz Festival (*www.nbjazzfest.com*) which features local and international stars.

eating in north beach

Café Divine - 1600 Stockton St (on the corner of Washington Square Park), 986-3414

Italian. This relatively new restaurant is already a favorite with the locals: partly because of the high ceilings and big windows with a view of Washington Square Park (see Hanging Out chapter); and partly because the food is simple and good. It's a tad pricey, though their prix fixe of soup, salad, and pasta is $15, which isn't bad. The "purgatorio" pizza - with caramelized onions, garlic and fried sage ($9) - is very popular, and so are the homemade desserts. Go when you want to splurge. They're open for breakfast, lunch, and dinner, and there's an outdoor terrace. On Thursday nights there's live acoustic music. Open: mon-fri 9-9; sat/sun 9am-10pm.

Golden Boy Pizza - 542 Green St (btwn Columbus & Grant), 982-9738

Pizza. A neighborhood institution, Golden Boy Pizza is the place to go if you've got a hankering for a thick crusty Sicilian slice. Pitchers of beer, good music, and pizza - what else is there? They're open late on Friday and Saturday for those late-night munchies. Open: sun-thurs 11:30-11:30; fri-sat 11:30-2am.

Gold Spike - 527 Columbus Ave (btwn Stockton & Union), 421-4591

Italian. This is an unpretentious, old-school Italian restaurant. The main room has a bar, tables with red and white checkered tablecloths, cozy booths, and a jukebox loaded with Frank Sinatra disks. The food isn't great, but it's a good deal for family-style dining. You can get six courses - soup, salad, pasta, a vegetable, main course and dessert, for $13.95. Now that's amore! For those with less ambitious stomachs, ordering á la carte is also an option. Open: mon/tues 5-10; fri/sat 5-10:30; sun 4:30-9:45.

Liguria Bakery - 1700 Stockton (at Filbert), 421-3786

Foccacia. This bakery is famous for it's delicious, flat Italian bread which they make thin and chewy. It costs from $3 to $5 for a piece and it comes in a several flavors, including pizza, raisin, and mushroom. There's no place to sit here, but there's a park across the street. They close when they've sold out of bread, so get there early to avoid disappointment. Open: mon-fri 8-5; sat 7-5; sun 8-12.

Mario's Bohemian Cigar Shop - 566 Columbus Ave (at Union), 362-0536
www.mariosbohemian.com

Italian. Located right across the street from Washington Square Park (see Hanging Out chapter), Mario's is a classic SF hang-out. Sitting at the bar or at one of the small tables can trans-

port you back to the North Beach of the '50s, when the Beats ruled the streets. It's a small place, so be prepared to get jostled a bit before finding a seat, but it's warm and friendly. Mario's specializes in sandwiches served on foccacia bread from a nearby bakery. My favorite is the grilled eggplant ($7.25). Pastas and salads are also available. North Beach can get clogged with tourists on weekends, so I suggest ducking in here for lunch on a weekday. Open: daily 10am-midnight.

Molinari Delicatessen - 373 Columbus Ave (at Vallejo), 421-4337

www.molinarideli.com

Take-out. The overwhelming variety of imported cheeses, wines, deli meats, and desserts in here will make your mouth water. Molinari has been in business for about 100 years and it's a landmark in the neighborhood. Order a sandwich (from $5.25 to $8) to take to the park, or pick up some quality ingredients to cook up later. Open: mon-fri 8am-6pm; sat 7:30am-5:30.

Gelato Classico - 576 Union St (at Stockton), 391-6667

Frozen dessert. Gelato is an Italian invention, so it's appropriate to have some when you're in North Beach. Gelato Classico makes delicious flavors like cappuccino, macadamia nut and Bavarian mint. The sorbet comes in lighter flavors like lemon and passion fruit. It's not particularly cheap, but for a truly North Beach experience, treat yourself to a couple of scoops, go sit on the grass in Washington Square Park, and enjoy. Open: sun-thurs noon-10pm; fri/sat 12-11pm.

book & music shopping

City Lights Bookstore - 261 Columbus Ave (at Jack Kerouac Alley), 362-8193

www.citylights.com

City Lights Bookstore and publishing company were both founded in 1953 by Lawrence Ferlinghetti, the famous Beat poet. It was the first place in the US to carry paperback books exclusively - with the philosophy of making literature more accessible. The shop was also a place for Beat writers to gather and hold readings. The contribution it has made and continues to make to American literature by supporting new writers, has ensured that it remains the most famous bookstore in town. The upstairs room is devoted entirely to poetry, and includes a wall of works by Beat writers. The back room on the main floor has a great selection of zines. As for the rest of this maze-like, multi-leveled shop, it's just jam-packed full of great reads. Go. Open: daily 10am-midnight.

City Lights Bookstore

Black Oak Books - 540 Broadway (btwn Columbus & Kearny), 986-3872

www.blackoakbooks.com

Black Oak is another great North Beach bookstore, with Beat literature and small press books immediately to the right as you enter. There's a small room in the back devoted to mystery and

sci-fi. Upstairs is a labyrinth of travel books, history, philosophy and much more. Their stock is both new and used. Open: mon-thur 10am-11pm; fri-sat 10am-midnight; sun 10am-11pm.

101 Music - 1414 Grant Ave (near Green), 392-6369

Outside, 101 Music is lined with black-and-white notes. Inside, the walls are lined with cassette tapes, and there are bins full of used vinyl and CDs. There are also acoustic and electric guitars hanging from the ceiling, making this a slightly claustrophobic place to browse, but often a rewarding one. The owner, Tom, is a music afficionado and serious collector, and he's been in the biz for over 20 years. Open: daily 12-8.

101 Music #2 - 513 Green St (at Grant), 392-6368

Around the corner from Music 101 you'll see a sign above a shop that just says "Records". Walk in and immerse yourself in the slightly dusty atmosphere. Make your way through the stacks of musical instruments and equipment to the back. If you dare to descend the basement stairs you'll believe you've died and gone to record collectors' heaven. Open: daily 12-8.

north beach bars

The Saloon - 1232 Grant Ave (at Columbus), 989-7666

www.sanfranciscoblues.net/saloon.html

The Saloon is one of the oldest bars in San Francisco. In the 1800s, this was a down-and-dirty corner where drunks who stumbled out of the building after visiting the prostitutes upstairs risked being shanghaied to work on the crew of some horrible ship. (Don't worry, that *probably* won't happen to you.) There's still a feel of the wild west in the bar, partly because it's so old, but also because the regulars who pack this rockin' joint really like to party. The Saloon was one of the first bars in town to feature live music and the focus here is the on the blues. In fact, a lot of recordings have been made in this place. In the 1960s, Janis Joplin liked to party here. Open: daily noon-2am.

Specs - 12 Adler St (near Columbus & Broadway), 421-2112

Across the street from City Lights Bookstore, in a cul de sac next to Tosca's (see below), you'll find this unique bar. Specs attracts a local, bohemian clientele and is packed with a strange combination of memorabilia, from antique nautical instruments harkening back to the Barbary Coast days of North Beach, to completely random items, like a gold toilet plunger. The choice of beer is terrible, but that's not why anyone comes here. Open: daily 5pm-2am.

Tosca's - 242 Columbus Ave (btwn Broadway & Pacific), 391-1244

Over the decades, a lot of famous people have hung out and played pool in their exclusive back room. You and I, however, will probably have to make do with the main room with its classic red leather decor, smokey atmosphere, and opera-spinning jukebox. Tosca's is a San Francisco landmark and well worth stepping into for an awesome booze-laced cappuccino or a late-night drink. Open: daily 5pm-2am.

Vesuvio - 255 Columbus Ave (at Jack Kerouac Alley)

www.vesuvio.com

Jack Kerouac and Dylan Thomas are just two of the celebrities who are known to have gotten drunk here. And it's said that this is where Francis Ford Coppola wrote most of The Godfather. Despite all this, Vesuvio is a laid-back and unpretentious place to have a pint. There's seating upstairs, too. Open: daily (including holidays) 6am-2am.

Purple Onion - 140 Columbus Ave (at Kearney & Pacific), 398-8415

www.purpleonioncomedy.com

This club was is legendary. Back in the '50s and '60s it featured some of the premiere comedy acts in the nation: Lenny Bruce, Woody Allen and Phyllis Diller all performed here. It's gone through various incarnations, but remains a great place to catch what's happening in the local comedy scene.

The Haight

Nostalgia for the sixties drives the economy in a large part of this district, especially in the Upper Haight (also known as Haight-Ashbury). But between the over-priced thrift shops and tourist traps flogging tie-dyed mementoes of the Summer of Love, you'll still find locally-owned businesses that retain some of the values of the 1960s. You'll also come across a lot of homeless people and young punks, many with bad drug problems, who gather at the top of Golden Gate Park. Be prepared to be panhandled. Where Haight Street meets Golden Gate Park is a particularly rough spot. Despite this, it's still worthwhile visiting this historic neighborhood that brought psychedelic drugs and music to the attention of the nation. If you're here in mid-June, look out for the Haight Street Fair (*www.haightstreetfair.org*). The Haight is bisected by Divisadero Street into two sections, Upper Haight (Haight-Ashbury) and Lower Haight.

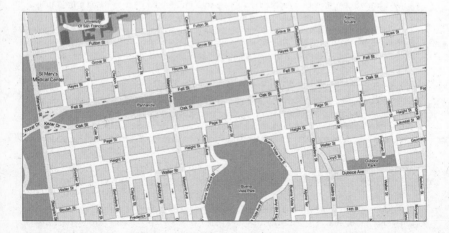

cafés in the haight

Café International - 508 Haight St (near Fillmore), 552-7390

This chefs at this café and performance space prepare Middle-Eastern food as well as home-made soups, and sandwiches on bread from local bakeries. It's a comfy space (try to grab the couch) and out back there's a sunny patio where smoking is permitted. The house band "Miles Ahead" plays jazz every Sunday from 4 to 9pm. On Friday nights they host open-mic poetry jams starting at 8pm. All in all it's a pleasant, bohemian-style joint - with internet ($3 for 20 minutes; $5/day or $15/month for wifi). Open: tues-thurs/sun 8am-10pm; sat 8am-7pm.

Coffee to the People - 1206 Masonic Ave (at Haight)

www.coffeetothepeople.com

These guys - relatively new kids on this block full of cafés - support neighborhood political activists and a portion of their profits also go to local charitable causes. That's cool. Their coffee is strong, organic and Fair Trade; and they serve matcha (a delicious, healthy Japanese green tea). Every Friday at 7:30pm they have an open-mic night. It's a laid-back place to chill, and if you've got a laptop they have **free wireless access**. Open: mon-thurs 6am-8pm; fri 6am-10pm; sat 7am-10pm; sun 7am-8pm.

Rockin' Java Coffee House - 1821 Haight St (btwn Shrader & Stanyan), 831-8832

www.rockinjava.com

The fresh, strong coffees brewing here are all organic and free trade. The teas, juices and food are also organic. Grab a bagel, sandwich, or a salad and head for Golden Gate Park which is only one block away. If the weather sucks, grab a cup of "foglifter" coffee and kick back on one of the couches. Computers with internet access are available ($3 for 10 minutes) and there's **free wireless service**. Also, there's a pool table in the back room. There are regular open-mic nights with acoustic music and poetry. Open: mon-sat 7:15am-10pm; sun 8:15am-10pm.

People's Café - 1419 Haight St (btwn Masonic & Ashbury), 553-8842

If you're craving greens, head to Peoples for one of their enormous bowls of salad (served with bread, $5 to $8). For breakfast, try their huevos rancheros - eggs, black beans, and salsa on a tortilla ($7.25). There's good people-watching through the big, sunny windows. Open: daily 7am-10pm.

Café Cole - 609 Cole St (at Haight), 668-7771

www.haightashburymerchants.com/ccgallery.html

Café Cole

Though it's barely off busy Haight street, this quaint little café with its nicely done wooden interior feels more peaceful than others in the neighborhood. They serve sandwiches ($3.95), calzones, and excellent blended juices and smoothies ($3.30). A shot of wheatgrass will cost you $1.25. There's plenty here for vegetarians and vegans. Grab a seat outside on the sidewalk if the weather's nice. Internet service costs $3 for 20 minutes. Open: 7am-8pm.

Sacred Grounds Coffee House - 2095 Hayes (at Cole), 387-3859

www.sacredgroundscafe.com

To experience an old-school-San-Francisco-open-mic poetry reading, drop in here on a Wednesday evening. Thursday through Saturday there's live music. It's a friendly neighborhood café with a cozy atmosphere and healthy eats. They serve tasty, inexpensive, home-cooked meals. Try their veggie lasagna ($5.95) or one of their yummy soups ($2.95 to $3.75). There's lots more on the menu including snacks and desserts. Open: mon/tues 7-7; wed/thurs/fri 7am-10pm; sat 9am-10pm; sun 9am-7pm.

eating in the haight

El Balazo - 1645 Haight (near Belvedere), 864-2162

Mexican. If you get a burrito craving while you're in The Haight, try one of the unique ones they put together here. The "Jerry's" - named after Jerry Garcia - has cactus and Mexican goat cheese ($5.45). Sit at the counter near the big front windows, or take your food upstairs to the brightly painted mezzanine and gaze out at the trees. Open: mon-sat 10am-10:30pm; sun 10am-10pm.

Ploy II - 1770 Haight St (btwn Cole & Shrader), 387-9224

Thai. You'll find this restaurant up a set of stairs and inside a cozy, converted flat. The Vegetable Tom-Yum soup (hot and sour) will cure what ails you ($6.25). If they're not sold out, be sure to order a fresh vegetable roll, too ($4.95). The menu is varied and includes lots of options for vegetarians. Open (for lunch): tues-sat 11:30am-3:00pm. Open (for dinner): daily 4-10.

Citrus Club - 1790 Haight St (btwn Cole & Shrader), 387-6366

California/Asian. There's nothing like a big bowl of steaming noodles on a foggy night. Citrus Club serves up a variety of medium-priced noodle dishes and soups (starting at $5.95). One of my favorite appetizers here is the Vietnamese barbeque tofu spring rolls ($4.95). There's plenty on offer for vegetarians and there are a few vegan options as well. Have a seat at the counter and watch the cooks dish it out. I recommend coming early for dinner, or you may find yourself waiting in a long line. Open: sun-thurs 11:30am-10pm; fri/sat 11:30am-11pm.

Best of Thai Noodle - 1418 Haight St (at Masonic), 552-3534

Thai. The cooks at this little noodle shop crank out excellent food. They make tasty rice dishes and spicy salads, but like the name says, noodles are their specialty. Whether they're fat or flat, in soup or stir-fried, the noodles here rule! Just writing about them is making me hungry. The interior design of this place is kind of odd - what's with the musical paraphernalia all over the walls? Open: daily 11am-1:30am.

Asqew - 1607 Haight St (at Clayton), 701-9301

www.asqewgrill.com

Grilled. Almost everything on the menu here is grilled, yet you still have a lot of different choices to make when you order. You can get a half or full order of skewers - meat, fish or veggies grilled on a stick - and you choose whether or not you want them on rice, couscous, polenta, garlic mashed potatoes, or salad. It's mix and match. On a cold San Francisco night I like the grilled Portobelo mushrooms on mashed potatoes ($7.95). As side dishes they offer corn on the cob, asparagus, artichoke hearts - and, yup, they're all grilled, too. The sauces

they've created for each type of skewer are also really good. It must be a decent place to work, because the grillers are always happy and friendly in their cute little matching blue suits. Open: daily 11:30am-10pm.

Kan Zaman Café - 1793 Haight St (at Shrader), 751-9656

Middle Eastern. The name of this place means "a long time ago" and it sums up the essence of what you'll find: traditional and inexpensive Arabic food in a cozy casbah atmosphere. They serve the best hummus this side of the Red Sea. They also have baba ghanoush, falafels, shish kebabs and more. Entrees cost from $8 to $14. Try to get a low table so you can lounge on some pillows while smoking your after dinner hookah. It's not cheap, but it's flavored with your choice of honey, strawberries or apricots, and you can share it with a whole table full of people. Try it with Arabic coffee for extra zoom, or warm, spiced wine as a special treat. Call to find out which nights the belly dancers are performing. Open: mon-thurs 5pm-midnight; fri 5pm-2am; sat noon-2am; sun noon-midnight.

Squat & Gobble - 1428 Haight St (btwn Masonic & Ashbury), 864-8484
237 Fillmore St (btwn Haight & Waller), 487-0551

www.squatandgobble.com

Crepes & more. Don't let the name turn you off: they serve pretty decent food here. I like the savory crepes stuffed with combos like cheese & onions, spinach & feta, or eggplant & olives. They also make delicious dessert crepes. Expect to pay between $6 and $8. Omelettes, soups, salads and sandwiches are on the menu as well. It tends to be much busier for breakfast than for lunch or dinner. Open: daily 8am-10pm.

Blue Front Café - 1430 Haight St (btwn Masonic & Ashbury), 252-5917

www.bluefrontcafe.com

Middle Eastern & Greek. They call themselves "The House of Wraps" and they specialize in falafel, hummus, and other goodies - all wrapped up in big pitas ($6-$7). There are also sandwiches, salads, and breakfast foods on the menu. Add a cup of hot soup to your order for only $1.50. It's a nice spot to hang out and watch the locals in their natural habitat. Open: sun-thurs 7:30am-10pm; fri/sat 7:30am-11pm.

Cha Cha Cha - 1801 Haight St (at Shrader), 386-5758

www.chachacha.citysearch.com

Caribbean. This is a popular spot to get wasted on sangria, especially since they don't take reservations and you may find yourself waiting at the bar on crowded weekend nights. The decor is fun, with religious icons adorning the walls. Big, Caribbean meals (mostly meat, but there are veggie options) cost about $13. They offer a lunch menu of sandwiches served with a salad and potatoes for around $6.75. And they serve tapas all day. Try the fried plantains with black beans and sour cream. If you bring along a printout of the "free flan" page on their website, they'll give you a free caramel coconut flan. Open: sun-thurs 11:30am-11pm; fri/sat 5pm-11:30pm.

All You Knead - 1466 Haight St (btwn Ashbury & Masonic), 552-4550

American. This is a very comfortable, diner-esque place with big, round red booths. They serve your basic comfort foods: lasagna, eggplant Parmesan, burgers (beef and veggie), fries and pizza. Breakfast is served until late afternoon. They whip up huge omelettes, pancakes, blintzes and scrambled tofu. Prices average about $5.50 to $8.50. The food is really nothing to write home about and the decor leaves much to be desired, but there's something about this place that I like anyway - it's perfect after a late night. Open: daily 8am-11pm.

Haight Street Market - 1530 Haight St (btwn Clayton & Ashbury), 255-0643

www.haightstreetmarket.com

Health Food. This neighborhood store is popular with the locals who come to shop for the fresh, seasonal fruit and vegetables, much of which is organic. Prices are very fair. So if an organic apple is what you really want to eat as you wander The Haight, stop in here. They also have lots of bulk foods, snacks, beauty products and vitamins. Open: mon-sat 7am-9pm; sun 8:30am-9pm.

Kate's Kitchen - 471 Haight St (btwn Fillmore & Webster), 626-3984

Breakfast. Kate's breakfasts are famous in the Lower Haight. And the place is small, so don't be surprised if you have to get on the waiting list for a table. The menu includes fresh fruit and granola, eggs, home fries with sauteed onions, french toast, tasty cheese biscuits and gravy, and homemade sausage. The gargantuan pancakes with maple syrup are enough for two people! In fact, all the servings are huge, so go here when you're really starving. The decor is homey, and the waitstaff are friendly. Open: mon 9am-2:45pm; tues-fri 8am-2:45pm; sat/sun 9am-3:45pm.

Axum - 698 Haight St (at Pierce), 252-7912

www.axumcafe.com

Ethiopian. The food here is served up Ethiopian style: it arrives on giant platters with a traditional pancake-like bread that you share with your friends. And best of all you get to eat with your hands! The veggie-combo plate ($7.60) is spicy, filling and delicious. Meat dishes average about $10. Beer and wine are available. For a dessert treat, try steamed milk and Kahlua. Open: daily 5pm-10:30pm.

Cuco's - 488 Haight St (btwn Fillmore & Webster), 863-4906

Mexican & Salvadoran. This is a true mom-and-pop taqueria. In fact, everyone in the family gets into the act: the teenage daughter works the register and the younger kids do homework at the tables. I highly recommend the plantain burrito - a perfect balance of sweet and savory, and a hearty meal for just $4.75. Open: mon-fri 12-9.

Love N Haight Deli - 553 Haight St (btwn Steiner & Fillmore), 252-8190

Sandwiches & salads. If you need to grab a bite between stops on a Lower Haight pub crawl, then stop in at this deli. Expect to pay from $5 to $7 for a big sandwich, falafel or salad. They're extremely vegetarian/vegan friendly and offer fake meats - such as mock duck, chicken or pepper steak. There are also good video games at the back. Open: mon-sat 11:30am-2am; sun 11:30am-1am.

shopping in the haight

Forever After Books - 1475 Haight St (btwn Ashbury & Clayton), 431-8299

Used books are literally piled up to the ceiling in here. What you're looking for is probably in there somewhere, but it might be hard to find on your own. The staff, however, will amaze you with their ability to seemingly find a needle in a haystack. There is often a $1 shelf outside the front door. Open: daily 11-8.

Bound Together - 1369 Haight St (btwn Masonic & Central), 431-8355

www.bapd.org/gbotks-1.html

Like all anarchist bookstores worthy of the name, Bound Together is collectively run by volunteers. They stock the usual social theorists on the evils of capitalism, but also lots of interesting zines, a healthy collection of right-on fiction and the publications of a wide variety of small left-wing and alternative presses. If you're in town in late March, ask here about the Anarchist Book Fair, an event where independent publishers sell their books at discount prices, and there are always interesting, well-known speakers. In the past I've seen Jello Biafra, Lawrence Ferlinghetti, Dennis Peron, and Kathy Acker. Bound Together is open daily 11:30-7:30.

Booksmith - 1644 Haight St (btwn Clayton & Cole), 863-8688

www.booksmith.com

For over 20 years now, this well-stocked, independent bookstore has hosted readings and book-signing events in The Haight. It's a great way to get signed copies of new releases. I like perusing the magazine section at the front of the store. Open: mon-sat 10-9; sun 10-6.

Groove Merchant Records - 687 Haight St (at Pierce), 252-5766

www.fogworld.com/gm

The Beastie Boys refer to this store by name on *Check Your Head*. They've got serious vinyl in here - rare groove, jazz, funk, acid jazz, Brazilian beats and a lot more. They cater to DJs and collectors. Open: daily 12-7.

Jack's Record Cellar - 254 Scott St (at Page), 431-3047

These guys have been here for more than 50 years! You wouldn't know it by looking at the non-descript front of the building, but they have an incredible library of rare vintage jazz, old rock and roll, stacks of 45s and old 78s, and lots of other stuff. There's a good selection of obscure, sleazy lounge music, too. Open: wed-sun 12-7, or by appointment.

Reverb Records - 1816 Haight St (btwn Shrader & Stanyan), 221-4142

www.reverbsf.com

Reverb is a DJ-run store that specializes in underground electronic dance music. There's a small selection of CDs, but this is mainly a wax joint and it's a regular stop for collectors searching out hard-to-find trance, breaks, electro, and other dance beats. Check it out. Open: mon-sat 12:30pm-8pm; sun 1-7.

Amoeba Records - 1855 Haight St (btwn Shrader & Stanyan), 831-1200

www.amoebamusic.com

What can I say... Amoeba is an amazing place to shop, but its sheer size has hurt a lot of small, local record stores. They sell new, used, and rare: CDs, tapes, vinyl, DVDs, videos, and posters. Prices start as low as $2. Check out their website or the free weekly papers for listings of their live in-store shows. I recently enjoyed seeing Excene Cervenka and John Doe of X here. Open: mon-sat 10:30am-10pm; sun 11-9.

Golden Triangle - 1334 Haight St (btwn Masonic & Central), 431-6764

There's no shortage of head shops in the Haight, but this one stocks a particularly good selection of glass pipes. Connoisseurs will also appreciate their wide variety of "vaporizers" - pipes with heat sources that "vaporize" rather than burn your smoking material. And currently

they're the exclusive sales point for bubblebags in San Francisco. At the back of the shop is the Kind Sanctuary, a medical cannabis dispensary, but you won't be allowed in there without a patient ID card (see Cannabis chapter). Open mon-sat 11-9; sun 11-8. (Upper Haight)

Giant Robot - 622 Shrader St (btwn Haight & Waller), 876-4773
www.gr-sf.com

Fans of *Giant Robot* magazine will definitely want to pay a visit to their SF store. Not only will you find the latest edition of this Asian culture mag, but also racks full of other cool publications - fanzines, art books, and graphic novels, both domestic and imported. The rest of the incredibly diverse items in this shop are largely of Asian origin, too. They stock all the newest, coolest and most collectable toys, gadgets, candy, DVDs, stationary, clothing and accessories. There are also regularly changing art exhibitions. This is an excellent place to pick up unique gifts for friends back home. Open: mon-sat 11:30-8; sun 12-7. (Upper Haight)

bars in the haight

Toronado - 547 Haight St (btwn Steiner & Pierce), 863-2276
www.toronado.com

For an excellent selection of European brews, including some kick-ass Belgian ales, check out this neighborhood watering hole. It's an agreeable place to knock back a few pints, especially during their happy hours (daily from 11:30am-6pm) when pints are $2.50. Open: daily 11:30am-2pm.

Noc Noc - 557 Haight St (btwn Steiner & Fillmore), 861-5811

For a complete change of pace from traditional pubs, drop into this tripped-out cave of a bar. I like the highly stylized decor in this place, from the low benches and cushions tucked into the corners, to the funky tall chairs at the bar. There's a club like atmosphere with black lights and DJs spinning on a regular basis - though the space is too small for any dancing. They only serve beer and wine, but they have a good selection. Pints are $2.50 during happy hour, from 5 to7:00. Open: daily 5pm-2am.

Murio's Trophy Room - 1811 Haight St (btwn Shrader & Stanyan), 752-2971

All sorts of people - from hard-core bikers to hard-core yuppies hang here comfortably. There are two pool tables, two TVs continuously screening sports events, neon beer signs, and big mirrors - all of which create a comfy, divey atmosphere. It's a classic American bar that reminds me of the kind of place I would have tried to sneak into when I was a teenager. Open: daily noon-2am.

Zam Zam - 1633 Haight St (btwn Clayton & Belvedere), 861-2545

Famous for their martinis, and infamous for the former owner - a quirky bully of a man named Bruno - this tiny, Persian-themed bar is clean, calm and beautiful. Despite a recent price hike, it's still an affordable, unique, and pleasant place to drink. Open: daily 3pm-2am.

Mad Dog in the Fog - 530 Haight St (btwn Fillmore & Steiner), 626-7279

Not surprisingly, they serve lots of decent beer at this British pub. They also serve traditional English breakfasts all day until 9:30pm. Monday and Thursday nights, starting at 9:00, they host a general knowledge pub quiz. It's a very popular event - particularly with the local British expats. Open: mon-fri 11:30am-2am; sat/sun 10am-2am.

Club Deluxe - 1511 Haight St (at Ashbury), 552-6949

www.clubdeluxesf.com

Big red vinyl booths and chrome touches give this stylish bar a 1940s ambience. There's an upright piano and a tiny stage where they squeeze in performers on their music, poetry and comedy nights. I prefer the mixed drinks to the slim selection of beers. Open: mon-fri 6pm-2am; sat/sun 2-2.

Gold Cane - 1569 Haight St (btwn Clayton & Ashbury), 626-1112

There's a pleasant back patio at this watering hole. Locals have been drinking here since the 1970s and it's become a neighborhood institution. Take a look at the photos in the back if you want to see how the place looked in the old days.. The mixed drinks are cheap and strong, and the jukebox features choice oldies, from Chet Baker to Jefferson Airplane. Open: daily noon-2am.

Magnolia Pub and Brewery - 1398 Haight St (corner of Masonic), 864-7468

www.magnoliapub.com

Beer lovers won't want to miss this pub. They brew their own ales in the basement and they've got something to suit every palate. Deadheads will get a kick out of the names: Weather Report Wheat, Stout of Circumstance, High Time Harvest. See the chalkboard menu for a description of the various brews on tap that day. The food is also excellent and fresh. The produce is mostly organic and the meat is free-range and locally raised. Their brunch menu is particularly popular. The interior is light and airy and is dominated by a big mural on the wall. Open: mon-thurs noon-midnight; fri noon-1am; sat 10am-1am; sun 10am-midnight.

famous tenants

Here are some addresses where famous people once lived. All of these places are obviously owned by other people now so don't be a dork and go bothering the residents. Do I even have to say that?

The Grateful Dead house: 710 Ashbury.

The Jefferson Airplane mansion: 2400 Fulton, at Willard North.

Janis Joplin's apartment: 112 Lyon Street.

Where the Manson family lived for awhile: 636 Cole.

Hunter S. Thompson wrote here: 318 Parnassus.

Chet Helms helped create the sound of the '60s by hosting jam sessions here: 1090 Page Street.

tender

The Tenderloin

L
egend has it that The Tenderloin got its name because that's the expensive cut of beef that a police officer could afford after a bribe-collecting visit to this crime and vice-ridden district. It's one of the oldest areas of San Francisco and even though it's surrounded by more upscale neighborhoods now, it remains pretty dodgy. The center of gay life in the city was here before it moved to The Castro and a few gay bars still line Polk Street. Recently, an influx of Southeast Asians immigrants has resulted in part of the neighborhood being dubbed "Little Saigon". In other parts of the district there's been some gentrification, but cheap housing, prostitution, and street drugs are more commonplace. The Tenderloin has lots of cheap eats, clubs, and lively streets, but don't expect a welcoming committee: this neighborhood doesn't pander to tourists.

eating & drinking

Ananda Fuara Vegetarian Restaurant - 1298 Market St (at 9th), 621-1994

Vegan/Vegetarian. I love this place. There is an almost cultish, new-age vibe here that some find hard to take, but the food is awesome! They serve up homemade soups, salads, pizzas, burritos, veggie burgers, smoothies, and delicious desserts. I recommend the "Neatloaf" sandwich (made from grains, tofu, cheese and eggs - $8.25) or the potato-tofu ravioli dinner ($8.95). Their fruit pie is a great way to top off your meal. Open: mon, tues, thurs, sat 8-8; wed 8am-3pm.

Dottie's True Blue Café - 522 Jones St (btwn Geary & O'Farrell), 885-2767

Breakfast. Dottie's is a San Francisco institution that is all about breakfast. Stacks of butter-milk pancakes spiced with ginger and cinnamon ($5.50), three egg omelettes with home fries and toast ($6.25), homemade breads and pastries: what a way to start your day. The neighborhood is a little rough, and the wait for a table can be long because the place is tiny, but it's all worth it. On Sunday mornings folks from the nearby church flood the place after services. It's not as cheap as the name of the place might suggest, but the food is great. Open: wed-mon 7:30am-3pm.

Golden Era - 572 O'Farrell (btwn Leavenworth & Jones), 673-3136

www.goldeneravegetarian.com

Vegetarian/Vegan Chinese. This affordable Chinese eatery is located in the lobby of an old apartment building. Its big round tables are almost always full of Asian families or dread-locked vegetarians. I was never one for faux meats until I tried the garlic beef here: now I can't get enough of those savory soy nuggets. Most dishes - soups, noodles, rice plates, curries - cost from $5.50 to $8. Open: wed-mon 11-9.

Gyro King - 25 Grove St (btwn Larkin & Hyde), 621-8313

Mediterranean. The huge and delicious falafels they serve here are worth going out of your way for. And at $4.95 they make for a cheap meal. There's not a whole lot of atmosphere in this place - the TV blares non-stop - but everything they cook is well-seasoned and tasty. There are many incredible desserts too, mostly involving layers of flaky filo dough drenched in

honey (so sweet they make my teeth hurt). The Gyro King is located directly across from the main library entrance (see Hanging Out chapter). Open: daily 7:30am-10pm.

Hahn's Hibachi - 1710 Polk St (at Clay), 776-1095
www.hahnshibachi.com

Korean. A friend who lived in Korea for many years turned me on to Hanh's and now it's one of my favorite places to eat in the Tenderloin. This family-run, Korean BBQ restaurant has several branches in the city (prices vary with the neighborhood) but I like this little storefront on Polk Street best. The veggie pot stickers ($3.95) are a delicious way to start off your meal.. Their veggie tempura ($5.95), tofu kabobs ($8.95), and udon noodle soup ($6.95) are also faves. Open: daily 11-10.

Shalimar - 532 Jones St (btwn O'Farrell & Geary), 928-0333
1409 Polk St (btwn Post & Geary), 776-4642
www.shalimarsf.com

Curry. If you don't mind crowds, noise, and intensely spicy aromas, come and experience this restaurant. Order up at the counter and take a seat. You can get a really decent curry here for just $5. Add their delicious garlic naan for another $2.50. There are lots of vegetarian dishes on the menu. They don't serve alcohol here, but you're welcome to bring in your own. Open: daily 12-3 & 5:30-11:30.

Tù Lan - 8 6th St (at Market), 626-0927

Vietnamese. This is somewhere you might not wander into on your own initiative, but don't let the seedy locale nor the fake wood paneling of the interior scare you off: this place is a reliable old favorite of many a San Franciscan. The food is delicious, extremely cheap ($4 to $6), and is served up fast by very friendly staff. Go! Open: mon-sat 11-9:30.

Aunt Charlie's Lounge - 133 Turk St (btwn Taylor & Jones), 441-2922
www.auntcharlieslounge.com

An authentic, long-established, gay, dive bar, Aunt Charlie's Lounge has cheap drinks and an interesting mix of regulars: drag queens, hipsters, street people... The highlight at Aunt Charlie's is the Friday and Saturday drag shows featuring the Hot Boxxx Girls. These "gender illusionists" are very old-school and some are actually quite, well...old. Tip them well - any guy who can look good in make-up and heels when he's sixty, deserves a tip. On Thursday nights, Tubesteak Connection with DJ Bus Station John pulls in a younger, hipper crowd. Aunt Charlie's Lounge is located in one of the sketchiest parts of the Tenderloin, so be aware of your surroundings, go with friends, and don't get too tipsy. Open: mon-wed noon to midnight; fri noon-2am; sat 10am-2am; sun 10am-midnight.

Edinburgh Castle Pub - 950 Geary Blvd (btwn Polk & Larkin), 885-4074
www.castlenews.com

Ever since Irvine Welsh read here in the '90s, this grotty pub has become a literary hangout. There are 20 good beers on tap here, including a fine selection of malts. You can also get fish 'n' chips the way they're supposed to be served - in newspaper, with vinegar on the table. They're pretty greasy and they actually get them from a place around the corner, but it's fun to eat them in the bar while drinking beer. Downstairs you can hang out and play pool and darts. Live music, films, readings and other special events happen in the smaller, upstairs space. Check *The Guardian* for details. Fish and chips are served until 11pm. Open: daily 5pm-2am.

The Owl Tree - 601 Post (at Taylor), 776-9344

I can't resist saying it: this place is a hoot! It's completely decked out with the most amazing collection of owl paraphernalia. They're everywhere - hanging off the walls, resting on the bar, and standing in every corner. The effect can be quite entertaining, especially after several of their inexpensive drinks. Low tables, '70s era chairs, and lots of brown and red create a retro mood that appeals to all kinds of drinkers. The salty snacks are free. Open: wed-sat 5pm-1am.

book shopping

A Clean, Well-lighted Place for Books
601 Van Ness Ave (btwn Turk & Golden Gate), 441-6670

www.bookstore.com

As the name implies, this independent bookstore is very well organized - and they have a huge selection. You'll find all the best in new fiction and non-fiction here. Maps, travel books, magazines, and newspapers are also stocked. Check their website or the free weekly papers (see Music chapter) for listings of special events and readings. You might just be able to meet one of your favorite authors in person here. Open: mon-sat 10-11; sun 10-9.

Kayo Books - 814 Post St (btwn Leavenworth & Hyde), 749-0554

www.kayobooks.com

This is John Waters' favorite book store in San Francisco. The collection of pulp fiction, sleaze-o-rama, sci-fi, horror, '60s sexploitation and '70s pop publications in this shop is truly awesome. I had difficulty deciding whether to list this place here or in the Museums chapter. There's a comfy chair upstairs where you can enjoy the effect of being completely surrounded by the beautifully lurid covers of the paperbacks. And if you decide that you want to pursue the equally lurid contents, you'll find the prices surprisingly affordable. Open: wed-sun 11-6.

McDonald's Books - 48 Turk St (one block from Market, btwn Mason & Taylor), 673-2235

Amid the urine-soaked sidewalks and cheeseball porn in this shitty neighborhood is an amazing shop with a vast collection of books on every topic you can think of. For book-lovers, shopping here can be a religious experience. Stuff is crammed onto sagging shelves and in general disarray throughout, so your browsing will involve some digging and hauling. Magazines dating from the 1960s are piled in the mezzanine. There's also an extensive used record collection. Happy hunting. Open: mon, tues, thurs 10-6; wed, fri, sat 10:30-6:45.

South of Market

SoMa, or the neighborhood located South of Market, is a light-industrial warehouse district. At night, its grid-like, deserted streets have long attracted those interested in something other than San Francisco quaintness. It's been the center of the gay community's leather subculture since the 1950s; and in the '70s it housed many bars and gay bathhouses. The spacious warehouse lofts were also attractive to artists, and in the '80s the neighborhood became a hub for the underground art scene. During the dot-com boom of the '90s the neighborhood underwent excessive development that displaced many of the people who once lived, worked, and partied here. Yet SoMa is still a bit rough around the edges and remnants of its wilder past remain. S/M fetish shops, art galleries, gay bars, and sex clubs thrive like weeds in the cracks of the gentrified sidewalk. And the kinky annual Folsom Street and Dore Alley Fairs are very much alive (see Sex chapter).

shopping in soma

Goodwill Industries "As Is" Shop - 86 11th St (btwn Market & Mission), 575-2197

www.sfgoodwill.com

This Goodwill is the mother of all Goodwills! Picture a warehouse full of giant bins overflowing with all the newest arrivals of donated clothing. Most of these items cost $2 each. When you hear a bell ring, step back because it means they're bringing out a new load. Sometimes it's really a madhouse in here. Open: daily 9am-3:30pm.

Stormy Leather - 1158 Howard St (btwn 7th & 8th), 626-1672

www.stormyleather.com/sf/store

This "women owned and operated leather, latex and toy shop" has a heavier attitude than Good Vibrations (see Sex chapter), but it's still a comfortable place for both men and women to shop. The store is huge and includes a dungeon area and a bridal registry (for those not interested in a white wedding). If you're at all curious about the S/M or B&D worlds, you should come here to have a look. The atmosphere is informative and not at all intimidating. To find the place, look for the large steel zipper out front. Open: daily noon-7pm.

Mr. S - 385 8th St (near Harrison), 863-7764

www.mr-s-leather.com

Catering mostly to gay men seriously into bondage and S/M, this shop stocks an awe-inspiring array of equipment. Have a peek at the metal cage with the full leather suspension gear and metal cross. They also sell strait jackets, some very no-nonsense chastity devices and a full line of latex and leather clothing. Open: mon-sat 11am-7pm.

One Taste - 1074 Folsom St (at 7th), 503-1100

www.onetastesf.com

Didn't bring anything on your trip to wear to a drop-in yoga class? How's about trying naked yoga? This place is called an "urban retreat" and it really is very peaceful in here. The yoga classes cost $12 each and are held upstairs in a beautifully serene room. Some of the co-ed classes are held in the buff too, but not all of them. Check their website or stop in and pick up a schedule inside the front door. Downstairs, you'll find The Feel Good Café where you can get a healthy juice drink and a salad or sandwich. Rejuvenate while relaxing on a couch in their mellow lounge or get a boxed lunch to go if the scene is too New Age for you. Open: mon-fri 8-8; sun 10-4.

drinking in soma

Brainwash Café and Laundromat - 1122 Folsom St (btwn 7th & 8th), 861-3663
www.brainwash.com

Not only is Brainwash the best place in town to do your laundry, it's also a bar and a performance space. Their very small stage area manages to accommodate acoustic shows, comedy nights, film screenings, and special events. The food and drinks could be cheaper, but there's an amazingly wide variety that'll meet just about any craving you've got. Burgers, sandwiches and dinner plates are in the $8 range and you can have a half-order if a healthy snack is what you're needing. Breakfast is around $5, is served all day, and includes an intriguing "This is Your Brain on Drugs" breakfast sandwich. The salads and soups are served with bread. The French Fries are particularly popular ($3.95 for a big plate). They also have a wide variety of hot and cold drinks as well as a beer and wine bar. There's no cover charge for any of the entertainment. By the way, the washing machines cost $2 per load, and soap is 60 cents. Kitchen closes at 10pm. Last wash in by 9:30. Open: mon-thurs 7am-11pm; fri-sat 7am-midnight; sun 8am-11pm.

The Eagle Tavern - 398 12 St (at Harrison), 626-0880
www.sfeagle.com

Both the interior and the customers' looks at this huge, famous leather bar can best be described as a hippie-biker, Mad-Max hybrid. But it's always a friendly crowd and it can get packed here, especially during their popular mud wrestling events or when they have a BBQ on the outdoor patio. It's mostly a men's bar, but they also host the occasional Leather Dyke Beerbust party, or a performance by the The Lesbian/Gay Chorus of San Francisco. Thursday nights there's live music and more women in the house. If you're lucky you may run into Virginia the Tamale Lady. She's a legend in SoMa and the Mission where she's been peddling her wares to late-night bar patrons for years. Open: daily noon-2am.

The Stud Bar - 399 9th St (at Harrison), 252-7883
www.studsf.com

The Stud is one of the most popular gay clubs in town. It feels like someone's rumpus room: wood paneling, a pool table and pinball machines in one room and a dance floor and small stage in the other. Drinks are cheap (as are most of the clientele) and the bar staff is friendly. On Tuesday night all roads lead to Trannyshack (*www.heklina.com*), especially if your stumbling down that road in a pair of five-inch heels. This very popular drag show features weekly themes that range from tributes to new drag icons like Björk to drag queen racing. Arrive early so you can get up front to see the show, but don't be surprised if you get splashed with fake blood or other fake body fluids. Also, many a queen has been known to stage dive. Other nights of the week feature DJs and dancing to indie, new wave house and techno. Open: tues, sat 5pm-4am; wed, fri, sun 5pm-2am.

The Tempest - 431 Natoma (btwn 5th & 6th), 495-1863

Bike messengers, punks, and rockers are the main clientele of this bar. It's a bit ugly and barren, but that's part of its charm. There's a pool table and, occasionally, loud live music. They also serve breakfast and lunch here, homey food like big omelettes, burgers, grilled cheese sandwiches, and tasty fries. The kitchen closes at 3pm. Open: mon, thurs, sun 7am-10pm; fri & sat 7am-2am.

The Richmond

Clement Street is the most popular destination in The Richmond. It's jam-packed with Asian restaurants of all sorts, but is a much less intense place to visit than Chinatown. The rest of the district is largely residential. The fog rolls in a lot quicker here than in other parts of the city, so dress accordingly if you plan to spend some time in the neighborhood.

eating & drinking

Burma Superstar - 305 Clement St (btwn 4th & 5th), 387-2147

www.burmasuperstar.com

Burmese. Influenced by the cuisine of its neighbors (China, India, Thailand and Laos), Burmese food incorporates elements of each into something distinctly its own. The traditional dishes offered at this homey little restaurant include curries, noodles, and Burmese samosas. Entree prices range from $6.75 to $13. Try to save room for fried banana with ice cream for dessert ($6.50). Everything I've tasted here has been exceptionally delicious. You may have to wait for a seat, but it's worth it. Open: sun-thurs 11am-9:30pm; fri/sat 11-10.

Good Luck Dim Sum - 736 Clement St (btwn 8th & 9th), 386-3388

Chinese. Incredibly cheap and delicious dim sum is served caféteria style here. Pick up a menu at the counter and circle what you want: seasame bean balls, shrimp dumplings, potstickers, and so on... There are generally 3 of each per order. Take a chance - even if you've never heard of it, it's likely to be delicious. The atmosphere can be hectic and the service less than charming, but you'll get a big pile of food for very little dough. It's mostly take-out, but there are a few tables at the back. Open: daily 7-7.

King of Thai Noodles - 639 Clement St (btwn 7th & 8th), 752-5198

www.kingofthainoodle.com

Noodles. This is actually a chain and there are a few branches scattered around the city, but this was the first one and it's my favorite. It's a small place that has a few tables in the back, and a few seats at the counter where you can watch them dish up your noodles. Udon, soba, lo mein... they have them all. Lunch prices range from $3.95 to $5.50 for a steaming bowl full. The counter is often filled with older Asian people, which is always a good sign. Open: daily 11am-1:30am.

Mama-san! - 312 8th Ave (btwn Clement & Geary), 221-9165

Sushi. This is a sweet, friendly mom-and-pop sushi restaurant in what looks like an old diner. There are just a few tables and a counter with stools. Everything is fresh, delicious, and prepared before your eyes. They offer vegetarian sushi options, as well as noodle soups and rice dishes. Expect to pay about $6.50 for lunch, and a buck or two more for dinner. Open: mon-sat 11:30am -9pm.

Blue Danube - 306 Clement St (near 4th), 221-9041

This comfortable, homey, somewhat run-down café is filled with artwork, from the picture-laden walls to the paintings on the tabletops. There's nothing pretentious here: they just serve good coffee and food that covers all your basic needs. It provides a pleasant respite from busy Clement Street. Though it's mostly a young crowd, all types of people hang here.

On Thursday nights they have various live acts, free of charge, which may include music, comedy or poetry. Open: mon-thurs 7am-11:30pm; fri/sat 7am-12:30am; sun 7am-10:30pm.

Toy Boat Dessert Café - 401 Clement St (at 5th), 751-7505

www.toyboatcafe.com

Craving some bee pollen or wheat germ? They'll toss some in your smoothie ($4.25) free of charge at this unique ice cream parlor. The entire interior of this otherwise old-fashioned-looking joint is decorated with cool toys and action figures: from Pee Wee Herman dolls to Godzilla and Jesus action figures - and they're all for sale. As for the menu, they serve soups ($2.75 to $3.50), salads ($5.75), and a wide range of sandwiches or wraps (with chips $4.50 to $6.50); but I come here for their awesome desserts. I highly recommend both the carrot cake and the cheesecake - oh, and the lychee ice cream, too. Yum. Open: mon-thurs 7:30am-11pm; fri 7:30am-midnight; sat 8:30am-midnight; sun 8:30am-11pm.

Velo Rouge Café - 798 Arguello (at McAllister), 752-7799

www.velorougecafe.com

This bicycle-themed café is a relatively new to the neighborhood and yet it's already a favorite with the locals. It's easy to spot: just look for their signature red bike hanging out front. Not surprisingly, they serve Red Bicyclette Chardonnay, and have Fat Tire beer on tap. They open early and their good, strong coffee will get your wheels spinning. The breakfast menu includes pancakes, waffles, eggs, and oatmeal with raisins. The rest of the day you can get the usual café fare. Open: mon-fri 6:30am-3pm; sat-sun 8am-6pm.

540 Club - 540 Clement St (btwn 6th & 7th), 752-7276

www.540-club.com

This is a community-minded bar - the walls are adorned with works by local artists and the exhibits change frequently. Red curtains, purple tablecloths, and friendly bartenders give this neighborhood place a warm and fuzzy atmosphere. They host all sorts of events, including dance nights, costume parties, and cocktail discount nights (Tuesdays from 10 to midnight; $2). It's a fun, cheap place to drink, shoot some pool, or play some darts - especially during their happy hours (mon-fri 4pm-7pm). **Free wifi**. Open: daily 10am-2am.

The Last Day Saloon - 406 Clement St (at 5th), 387-6343

www.lastdaysaloon.com

The second floor of this bar has a big stage, a great sound system and plaques lining the walls with the names of various bands who have played here over the past 30 years. They include some pretty big names in rock, funk, R&B, and comedy. Nowadays they mainly host local and touring indie bands. Downstairs, most of the patrons are regulars and it's not a hipster hangout: there are pool tables and video games, and it feels like a bar in a small town. Happy Hour is every afternoon from 2 to 6:00. Open: daily 2-2.

Trad'r Sam's - 6150 Geary Blvd (at 26th), 221-0773

This tacky tiki cocktail bar has more wood-paneling than pure Polynesian decor, but you do get private booths with a pseudo-island theme. Definitely order the Scorpion Bowl ($12) and share it with a couple of friends. Watch out, though: those things creep up on you! They also serve an intriguing drink called "Surfer on Acid", but it's $6.50 for a one person serving - outta my price range. Open: daily 10am-2am.

shopping in the richmond

Green Apple Books - 506 Clement St (btwn 5th & 6th), 387-2272

www.greenapplebooks.com

This might be the best bookstore in the city. It's a great place to browse and it's big enough that you can do it for hours. Have a look at the recommended readings on the first floor then head upstairs to the mammoth used section. There is a huge magazine section, too, with many hundreds of titles. Two doors down you'll find their annex, with a large selection of new and used CDs, records, tapes, and a particularly good listening station. Open: sun-thurs 10am-10:30pm; fri/sat 10am-11:30pm.

Kamei Household Wares - 547 Clement St (at 5th), 666-3688

You'll find the most amazing gadgets, sushi gear and ceramics in this Japanese housewares shop. There are aisles and aisles of shelves packed with handy, inexpensive, and surprising stuff. You might just find the perfect gift for that special someone back home: who wouldn't enjoy owning a mini rice cooker? Open: daily 9-7.

The Sunset

Despite its bright sounding name, The Sunset district actually has some of the foggiest weather in the city, particularly in the summer months. But armed with a couple of extra layers of clothing, visitors will enjoy exploring the livelier parts of this area. The district is divided in two: The Outer Sunset consists mostly of many miles of row upon repetitious row of little bungalows and stucco houses. The Inner Sunset is also largely residential, but with more of a small town feel and a reputation for good restaurants that reflect the ethnic diversity of the district. Inner Sunset borders on Golden Gate Park and The Haight.

sunset eating & drinking

Arizmendi Bakery - 1331 9th Ave (btwn Irving & Judah), 566-3117

www.arizmendibakery.org

Not only is this one of the best bakeries in town, it's a collectively owned-and-operated business. Excellent breads, scones, cookies, granola, focaccia and other highly delectable items are baked on the premises by members of the hard-working collective. Their pizza is superb and features gourmet toppings. The bakery is located just a short walk from the entrance to the Botanical Gardens in Golden Gate Park (see Hanging Out chapter), making it an ideal place to go for picnic food. Open: tues-fri: 7-7; sat: 8-7; sun: 8-4. (Inner Sunset)

Art's Café - 747 Irving St (near 9th), 665-7440

This tiny, neighborhood joint has been serving up traditional diner breakfasts since the 1940s - and people still often line up for them. I recommend the hash brown sandwich ($4.50): fried, grated potatoes folded over your choice of eggs and melted cheese or veggies. Nowadays, you can order Korean barbeque dishes here too. The only seating in the narrow storefront is on stools along the counter, facing the chef and the grill - charmingly old-school American. Postcards from customers, sent from all over the world, are sandwiched under glass on the counter top and testify to the appreciation this place inspires. Open: daily 7am-4:30pm. (Inner Sunset)

Howard's Café - 1309 9th Ave (btwn Judah & Irving), 564-4723

Most of the costumers at this diner are regularswho come for the inexpensive, reliable food, and the welcoming vibe from the friendly waitstaff. The eggs benedict with corned beef hash is a very popular item. I come for the home-made pies and cakes. Breakfast is served until 3pm, but whatever meal you go for, you'll come out with a full belly and change in your pocket. Open: mon-fri 7am-9pm; sat/sun 8am-3pm. (Inner Sunset)

Park Chow - 1238 9th Ave (btwn Irving & Judah), 665-9912

Italian pastas, Asian noodles, American sandwiches, and lots of meat dishes (about $6 to $10) are on the menu at this big restaurant, but you're most likely to choose this place for the space itself. They have attractive, heated outdoor seating upstairs; and a fireplace in the beam-ceilinged room downstairs - perfect on a foggy evening after a day spent in nearby Golden Gate park or at Ocean Beach (see Hanging Out chapter). Open: mon-thurs 11-10; fri 11-11; sat 10-11; sun 10-10. (Inner Sunset)

Peasant Pies - 1039 Irving St (at 12th), 731-1938

www.peasantpies.com

These are the cutest little pies you've ever seen. They come in both sweet and savory flavors and there are lots of vegetarian and vegan combinations. I recommend both the curried yam and the spicy eggplant with black olives. Get a dessert pie too, and you've got a convenient meal that you can eat anywhere. You get a slight deal if you buy more than one ($2.35 each instead of $2.55). They can heat them up for you in the store, but if you're taking them to go, don't bother; they're good cold, too. There's also a branch in Noe Valley (see Other Districts chapter). Open: mon-sat 9:30am-7pm; sun 10-7. (Inner Sunset)

The Beanery - 1307 9th Avenue (btwn Irving & Judah), 661-1090

Stop in for a strong cuppa joe at this neighborhood shop. The beans are roasted and ground on the premises. They sell all kinds of coffee including espresso and fair-trade, organic blends. They've got tea, too. Get it to go - Golden Gate Park is just a block away. Open: daily 6am-8pm. (Inner Sunset)

The Canvas - 1200 9th Avenue (at Lincoln Way), 504-0064

www.thecanvasgallery.com

This stylish café draws a young, arty crowd. The interior is spacious and doubles as an art gallery. In the daytime it's a comfortable place to work with your laptop or kick back and read. They have **free wifi** Monday to Fridays from 8 to 7pm, and weekends from 8 to 2pm. The food is a bit pricey, but the menu is extensive and appealing. They serve breakfast items and sandwiches that start at about $5, and entrees run about $9, but you can also just get a coffee and a cookie. There are performances and events almost every night of the week, ranging from cruisey club nights to poetry readings. All this plus a fireplace, cushy sofas, and a view of Golden Gate Park make it well worth a visit. Open: sun-thurs 8am-midnight; fri/sat 8am-2am. (Inner Sunset)

Java Beach Café - 1396 La Playa (at Judah), 665-5282

www.javabeachcafe.com

One very pleasant way to spend an afternoon is to take the N-Judah MUNI train to the end of the line, which brings you right to this great café. It's well-known by surfers as a place to chill out after hitting the waves at Ocean Beach. Bagels, sandwiches, salads and sweet things are available, and the coffee is super strong and roasted locally. To make the sunset even more enjoyable, order some beer or wine and sit outside. When it gets cold, move indoors to the cozy chairs in the back. The old wooden piano and the driftwood lying around give the place a rustic, cottage-like feeling. The regular crowd tends to be slightly older and very friendly. They have **free wireless** internet service. Open: daily 7am-11pm. (Outer Sunset)

Other Districts

the fillmore

Music lovers will have heard of the Fillmore long before visiting San Francisco. In the '40s the area was world-renowned for its jazz scene and almost every great artist of the era spent time here. In the '60s, the coolest musicians of every genre played the Fillmore Auditorium. Nowadays, bands are still rocking the Fillmore, and John Lee Hooker's Boom Boom Room around the corner is blues and funk central (see Music chapter). Other traces of its heyday as one of the nation's most vibrant African-American communities can be found in the area's population and businesses. Check out the vast collection of African American literature and history books at the **Marcus Book Store** (1712 Fillmore, btwn Post & Sutter; 346 4222; open: mon sat 10-7; sun 12-5). Or stop in at **Eddie's Café** for some delicious, inexpensive, soul food (800 Divisadero, at Fulton; 563 9780; open: daily 9 4). Parts of the Fillmore are a bit rough, while other sections have become somewhat gentrified. Strolling around, you'll find plenty to see, eat and buy. Look for **Comix Experience** (305 Divisadero, btwn Page & Oak; 863 9258; *www.comixexperience.com*) which has an amazing selection. And Open Mind Music (342 Divisadero, at Oak; 621 2244; *www.openmindmusic.com*) has particularly knowledgeable

staff to help you "find that CD or record that you didn't know you were looking for". The Fillmore is actually an area within the Western Addition district and borders on Japantown.

japantown

Japantown (*www.sfjapantown.org*) once covered some 30 square blocks of the Western Addition District. Now, though it remains the largest Japanese neighborhood in the US, it covers just a small area. The reason for this is that only a fraction of the residents returned after the shameful period during WW II when Japanese businesses and homes were confiscated and the owners were locked up in internment camps. The **Japan Center**, opened in 1968, caters to the Japanese population that remains in San Francisco. It's a huge mall, covering three square blocks on Geary Boulevard (btwn Fillmore & Laguna), and it's filled with Japanese shops and restaurants, a cinema, and a bathhouse (see Hanging Out chapter). One of my favorite places to eat when I'm here is the cute restaurant located on the bridge between the two halves of the Japan Center. Not surprisingly, it's called **On The Bridge** and they serve *yoshoku* - a hybrid of Japanese and Western European cooking that is very popular in Japan these days (open daily 1:30pm-10pm). If you're interested in Japanese popular culture, be sure to check out the enormous **Kinokuniya Bookstore** (2nd floor, btwn Buchanan & Webster; 567-3524). They stock books, graphic novels, magazines, t-shirts, toys, calendars, artwork, CDs and more: lots of unique items that would make great gifts for the folks back home. (Japan Center is open: mon-fri 10-10; sat/sun 9-10.)

noe valley

Noe Valley is a low-key neighborhood that feels like a small town. It's a comfortable, easygoing (though not cheap) place to live. It's also heaven for bagel lovers. I recommend those prepared by **Noe Bagels** (3933 24th St, btwn Noe & Sanchez; 643-9634; open daily 6-6): they have just the right ratio of chewy crust to squishy interior. The main shopping drag is on 24th Street from Church to Castro, and this is where you'll find a **Peasant Pies** branch (at 4108; see Sunset chapter); **Phoenix Books & Records** (at 3850; sister shop to Dog Eared Books; see Mission chapter); the **Global Exchange Fair Trade Store** (at 4018); and my favorite bakery for cakes and tarts - **Noe Valley Bakery** (at 4073). If you're around on a Saturday morning, be sure to stop in at the Farmers' Market (see Food chapter). By the way, Noe is pronounced No-ee.

Fritz Fries

hayes valley

In one of those odd urban mixes that have become so familiar to North-American city dwellers since the '80s, Hayes Valley is a district where chic shops and cafés stand shoulder-to-shoulder with low-income housing projects. On the extremely gentrified stretch of Hayes Street from Van Ness Avenue to Laguna

Street, you'll find up-scale art galleries, expensive cocktail bars, and unique boutiques like the ultra-stylish travel store, **Flight 001**. But you'll also find a record shop that "provides underground vinyl DJ support" (**BPM Music Factory**; 573 Hayes Street; 487-8680; open: daily 12-7) and a café that specializes in authentic Belgian fries (**Fritz**; 579 Hayes; 864-7654; open: daily 10-9; fri/sat 'til 12) both of which might make a visit worthwhile.

cole valley

Despite its proximity to The Haight, Cole Valley is a distinct community. For one thing, though people come from all over town to eat at the local restaurants, its much less hectic than The Haight. Technically, many of the residents could be classified as falling into the yuppie category, but the area doesn't have that flavor at all. The shops and eating places are almost exclusively of the mom-and-pop variety. For chilling out, I recommend the Reverie Café (648 Cole, at Carl; open daily 7-10), where you'll find blissfully strong coffee, croissants, gelato, free wireless service, and a peaceful, sunny back deck. If you want to splurge on a gourmet brunch, check out Zazie, (941 Cole, at Parnassus; 564-5332; open mon-fri 8-2:30; sat/sun 9-3). Their prix-fixe menu is just under $20 and includes one of their famously decadent desserts.

bernal heights

This neighborhood is tucked just below Bernal Hill, and it feels somewhat isolated from the rest of the city. Especially - as is often the case - when it's sunny up here and foggy below. The main shopping strip is along Cortland Street, where there are also many restaurants and cafés ranging from inexpensive to more up-scale. One of my favorite spots is **Progressive Grounds**, which has a fireplace inside, a lovely patio out back, and better-than-average café fare (400 Cortland, at Bennington; open daily 7:30am-9pm). **Wild Side West** (424 Cortland Ave, at Wool; open daily 1pm-2am) is basically a lesbian bar, but men are welcome, too. They have a great garden (open til 9:30), with seating and tables tucked into cozy nooks and crannies.

Bernal Hill

The narrow streets of the rest of the district are lined with cute bungalows and it's pleasant to wander through them, up Bernal Hill (see Awesome Views, Hanging Out chapter). If you take the back way, from Cortland, you'll pass some particularly sweet homes and gardens.

Film

From *Vertigo* to *Bullitt* to *The Last Waltz*, San Francisco has long been a favorite location for shooting films. It's also a great city for cinema enthusiasts: on any night of the week you'll find a wide variety of movies playing at rep and mainstream theaters throughout town. I've listed my favorite venues below.

The best way to find out which films are showing is to consult the free weekly newspapers (see How To Find Out Who's Playing, Music chapter). Remember to check if the venue offers matinee discounts. Regular screenings usually cost between $8 and $10, while matinee prices are in the $6 to $8 range. A few of the independent theaters print their schedules in flyer format. You can pick these up in cafés and restaurants.

If you have access to a VCR or DVD player, you might want to take advantage of some of the excellent rental shops in town. **Le Video** has every film you've ever heard of, and many you haven't: 1231 9th Avenue (btwn Lincoln Way & Irving St, in Sunset; 242-2120). **Naked Eye** has a great cult selection: 533 Haight Street (btwn Fillmore & Steiner; 864-2985). **Leather Tongue** also specializes in cult videos: 714 Valencia (at 18th, in the Mission; 552-2900). And **Lost Weekend** has sections dedicated to directors, gay and lesbian themes, and classics - new and old: 1034 Valencia (btwn 20th & 21st; 643-3373). Several of these stores also have sections devoted to movies that were filmed in San Francisco.

theaters

The Red Vic Movie House - 1727 Haight St (btwn Cole & Shrader), 668-3994

www.redvicmoviehouse.com

The Red Vic is collectively owned and operated and has been in business for over 25 years. They show a diverse mix of cult and foreign films, as well as second-run Hollywood flicks, and political documentaries. They also premiere works by local, independent film makers. There's a friendly, homey vibe at the Red Vic - many of the theater's seats are comfy padded benches, their strong organic coffee comes in a real mug, and the cookies and brownies are made locally. The popcorn is the best in town: organic and served in wooden bowls with real butter or a range of unique toppings (including nutritional yeast). Admission is $8 in the evening and $6 for the 2:00 matinees on Wednesdays, Saturdays and Sundays. You can pick up their calendar in cafés and bookstores around town. (Haight-Ashbury)

The Roxie - 3117 16th St (btwn Mission & Valencia), 863-1087

www.roxie.com

This is a well-respected art-house theater whose creative programming includes retrospectives, foreign films and political documentaries. They've recently opened the Little Roxie two doors down. Buy tickets for both theaters at the main box office. Tickets for the first show on Monday, Wednesday and Saturday are only $5. (Mission)

Artists Television Access (ATA) - 992 Valencia St (btwn 20th & 21st), 824-3890

www.atasite.org

These folks have been screening underground videos and film in their non-profit space since the early '80s. They offer multi-media workshops, video editing equipment rental, and Mac lab time, all at rates that are affordable for starving artists. They also host the Bay Area's only open submissions screenings. Pick up a copy of their program schedule outside their door, or check out their site. Admission is usually in the $5 range. (Mission)

The Castro - 429 Castro St (btwn Market & 18th), 621-6120

www.thecastro.com

They call this theater the "Jewel of the Castro" and one look at the decor will tell you why. It has a stylin' lobby and theater. It's well worth the price of admission just to experience the Wurlitzer guy sinking into the orchestra pit before every film. It's a great place to see old classics on a giant screen. The venue is often used for film festivals, including the Silent Film Festival (*www.silentfilm.org*) in early July. (Castro)

Balboa Theater - 3630 Balboa St (at 38th Ave), 221-8184

www.balboamovies.com

It's worth a trip to the Outer Richmond district to visit this cool movie theater. Screening a mix of Hollywood, independent, foreign and documentary films, the Balboa is a neighborhood theater that offers quality programming. They sell unique snacks at their concession counter, including veggie hotdogs. Film buff and manager Roger Paul often presents trivia quizzes and fun-packs before the show. Take MUNI 5, 31, or 38. (Outer Richmond)

IMAX - Loews Metreon Theatres, 101 4th St (at Mission), 369-6201

www.metreon.com

Those of you who enjoy aliens in your face, cars chasing each other off the screen, and super heroes flying over your seat, should head for this IMAX theater that often features 3-D films on its huge screen. It's located in a megaplex with 14 other halls, in an enormous mall (the Metreon Sony Entertainment Center). The mall, with its high-tech gaming arcades and electronic stores, can be a sensory overload in itself. Tickets for the IMAX shows cost $15.

film festivals

There are film festivals in San Francisco all year round and on every imaginable theme. Here are a few that I always look forward to. If you're film buff, be sure to scope out the festival scene before you come: many sell their tickets well in advance.

SF Indie Fest
early February at the Roxie Cinema & Women's Building.

www.sfindie.com

SF International Asian American Film Festival
mid-March at The Castro & AMC Kabuki 8.

www.naatanet.org

Hi/lo Film Festival (Hi concept/low budget short films)
mid-April at the Red Vic Movie House.

www.hilofilmfestival.com

SF International Film Festival
late April at The Castro & AMC Kabuki 8.

www.sfiff.org

SF Doc Fest
mid-May at the Roxie Cinema & Women's Building.

www.sfindie.com/docfest

San Francisco Black Film Festival
early June at the AMC Kabuki 8 & other venues.

www.sfbff.org

Lesbian/Gay/Bisexual/Transgender Film Fest (Frameline)
mid-June at The Castro, the Roxie & Victoria Theater.

www.frameline.org/festival

Madcat Women's International Film Festival
mid-September at El Rio, Yerba Buena Center & ATA.

www.madcatfilmfestival.org

ResFest: Digital Film Festival
mid/late September at the Palace of Fine Arts.

www.resfest.com

Bicycle Film Festival
early October.

www.bicyclefilmfestival.com

Film Arts Foundation Film Festival
mid-October at the Roxie Cinema.

www.filmarts.org

Music

San Francisco is overflowing with live music and dance venues. From famous concert halls and trendy clubs to dive bars and local community centers, there's a scene for your every mood.

For big-name shows you often need to buy tickets in advance, of course. Avoid Ticketmaster outlets which are a rip-off, and try calling the venue to find out if you can purchase them at the box office.

how to find out who's playing

All the following newspapers are free and can be easily found in paper boxes or in cafés and restaurants throughout the city. For the gay-oriented papers, check the cafés and bars in the Castro.

The Bay Guardian

www.sfbg.com

This independent, alternative newspaper has been around since the 1960s. It comes out every Wednesday and includes a comprehensive listing of the week's events in music and all the arts, as well as articles on local politics.

The SF Weekly

www.sfweekly.com

Complete events listings can be found in this paper, as well. It's also published every Wednesday.

Bay Times

www.sfbaytimes.com

Events in the gay, lesbian, bisexual, and transgendered communities are announced in this paper every other Thursday.

live music venues - the big ones

The Fillmore - 1805 Geary Blvd (at Fillmore), 346-6000

www.thefillmore.com

During its heyday, this historic concert hall was run by Bill Graham, the famous promoter. Its name is synonymous with the 1960s San Francisco music scene, but it's still a great place to see bands. While you're there, be sure to check out the impressive old photos and posters displayed in the balcony. If you're lucky, they'll hand out posters for the show you just saw as you're exiting the theater. Save service charges by buying tickets directly from the box office. Open: sun 10am-4pm, and show nights 7:30pm-10pm. (Fillmore/Western Addition)

The Great American Music Hall - 859 O'Farrell St (Polk & Larkin), 885-0750

www.musichallsf.com

A variety of contemporary music, including jazz, folk, and "world music" is presented in this large, ornately decorated venue. The stage was once used as a set for an orgy scene in the movie *The Resurrection of Eve*, starring local porn-queen Marilyn Chambers. (Tenderloin)

Maritime Hall - 450 Harrison St (between 4th & 5th), 974-0634

An old union hall turned music venue, Maritime Hall has a great sound system and management that cares about creating a good environment for the audience. (South of Market)

The Warfield - 982 Market St (at 6th), 775-7722

www.thefillmore.com/warfield.asp

The Warfield has gone through several incarnations since it was built in the '20s. It's been a vaudeville playhouse, a movie theater, and since 1978, a concert hall. All the greats have passed through this famous venue at one time or another and its plush interior makes it a beautiful place to see a show. (Civic Center)

Jerry Garcia Amphitheater - 40 John F. Shelley Drive (McLaren Park)

Ten years after the death of legendary guitarist Jerry Garcia, the city of San Francisco officially opened this 600 seat amphitheater in the neighborhood where he grew up. A good time to check it out is on August 6th, "Jerry Day" when fans converge from all over to celebrate his birthday. (Excelsior)

live music - smaller venues

Bimbo's 365 Club - 1025 Columbus Ave (at Chestnut), 474-0365

www.bimbos365club.com

Bimbo's moved from its original Market Street home to this location in 1951, and its plush interior still has that '50s feel. It used to feature chorus lines and showgirls; now it's an important venue for jazz and blues. Ticket prices start at about $10 and are available at the box office Monday to Friday 10 to 4:00. In October, some of the excellent **SF Jazz Festival** (*www.sfjazz.com*) is hosted here. (North Beach)

Bruno's - 2389 Mission St (btwn 20th & 21st), 643-5200

www.brunoslive.com

Luxurious red booths and a swanky atmosphere make this a perfect place to take in one of the classic jazz acts that Bruno's has been famous for since the '40s; though nowadays their program also includes everything from funk and latin jazz, to gospel and weird lounge acts. They serve delicious meals here too, but they ain't cheap. (Mission)

Slim's - 333 11th St (btwn Folsom & Harrison), 522-0333

www.slims-sf.com

It's well worth checking out Slim's schedule while you're in town. They bill themselves as a place that specializes in American roots music, but they actually book all kinds of bands. They're open three or four nights a week, and if you eat there (burgers, fries, and the like), you get priority seating. The space is roomy and there's a balcony at the back. (South of Market)

The Independent - 628 Divisadero (at Hayes), 771-1421

www.theindependentsf.com

This is an excellent new venue, but live music has been happening at this same address for over 30 years. Some big names play here and there's music of some kind almost every night. It's also one of the sites of the cool **Noise Pop Festival** in February (www.noisepop.com). Definitely check out the schedule while you're visiting. Buy your tix in advance, as shows here often sell out. Box office open: mon-fri 11-6; 'til 9 on show nights. (Western Addition)

Bottom of the Hill - 1233 17th St (btwn Missouri & Texas), 621-4455

www.bottomofthehill.com

Bands play here seven nights a week: rock 'n' roll, rock-a-billy, pop, folk, and hard rock. The slightly twisted and off-kilter decor creates a surreal feeling. There's a smoking patio out back. Wednesday to Friday there are happy hour specials from 4 to 7:00 and that's a good time to shoot some pool or grab a veggie burger and some of their tasty fries. The rest of the week they open at 8:30pm. (Potrero Hill)

Café Du Nord - 2170 Market St (btwn Church & Sanchez), 296-8696

www.cafedunord.com

During prohibition, this venue was a speak-easy and it still has that sort of atmosphere: it's a classy-looking joint, with dark wood and red walls. Café Du Nord is located in the beautiful, historic Swedish American building. Local and international musicians from every genre play in the hall upstairs and in the bar below. Also presented here is the very popular open-mic "'Porch Light" storytelling series, in which brave souls have 10 minutes to tell a story to the audience. It's an eclectic slice of SF life and I highly recommend it. Cover ranges from $7 to $15. (Outer Castro)

Elbo Room - 647 Valencia St (at 17th), 552-7788

www.elbo.com

The Elbo Room has been an entertainment facility for decades and it's a San Francisco institution. The club consists of a downstairs bar that draws a lively, trendy crowd; and an upstairs hall with a stage and dance floor where live bands and DJs play. The music runs the gamut from jazz, funk and afrobeat, to hip hop, indie and pop. They open daily at 5:00, with happy hour specials in effect until 9:00. (Mission)

Hotel Utah - 500 4th St (at Bryant), 431-2388

www.thehotelutahsaloon.com

According to the Hotel Utah website, Marilyn Monroe, Joe DiMaggio and Bing Crosby all drank here. They should add my name to that list. The stage here is quite small, but it's a nice place to see (mostly) local talent perform. The bartenders behind the big, old wooden bar are friendly and serve up a full menu of better-than-average bar food. There's **free wireless service**. Cover ranges from free to $10. Open: mon-fri 11:30am-2am; sat/sun 6pm-2am.(South of Market)

Rickshaw Stop - 155 Fell St (btwn Van Ness & Franklin), 861-2011

www.rickshawstop.com

Formerly a television studio, this large, split-level space has been warmed up with floor-to-ceiling red velvet drapes, comfy chairs, and decorative vintage rickshaws. Drinks are cheap, and so are the snack foods (corn dog with potatoes - $4). It's a fun and casual place for a night out with friends. There's live music or DJs spinning every night from Wednesday to Saturday. The cover is usually between $5 and $10 and the doors generally open at 8pm. (Hayes Valley)

Hemlock Tavern - 1131 Polk St (btwn Post & Sutter), 923-0923

www.hemlocktavern.com

This is a large but intimate bar with two levels, a live music room, a smoking lounge, and lots of cozy seating. There's a great jukebox, a pool table, and warm peanuts for $1 a bag. It's free to listen to DJs in the bar, but there's a cover charge of $5 to $8 for the back room where they present live music most nights of the week. Drinks are $1 off during happy hour, from 4 to 7:00. Open: daily 4pm-2am. (Tenderloin)

12 Galaxies - 2565 Mission St (btwn 21 & 22), 970-9777

www.12galaxies.com

This classy-looking bar seems small at first but it's actually quite spacious. Downstairs there's a bar, dance floor and stage. Upstairs there's a pool table, another bar, couches, and a view of the action below. It's a comfortable place to see both the local and famous touring bands that play here. Tickets are in the $7 to $15 range. (Mission)

El Rio - 3158 Mission St (at Cesar Chavez), 282-3325

www.elriosf.com

Famous for its patio, banana trees, and its funky, friendly, mixed crowd and programming, El Rio presents live bands and dancing several nights a week. It's always a great party and drinks are reasonably priced.' Cover ranges from nil to seven bucks. In mid-September they screen films here as part of the Madcat Women's Film Fest (see Film chapter). Open: mon-thurs 5pm-2am; fri/sun 3-2. (Mission)

Amnesia - 853 Valencia St (btwn 19th & 20th), 970-0012

www.amnesiathebar.com

Its location in the middle of the Valencia Street corridor, makes this is a fun place to round out a day spent sightseeing in the Mission. Local bands play music that ranges from jazz and blue-grass to indie rock and old-school hip hop. Underground DJs also spin here and that's when the dance floor heats up. They have an excellent selection of micro brews and Belgian ales on tap. Happy hour is daily from 6 to 8:00. The cover charge is usually free or very low. (Mission)

Noe Valley Ministry - 1021 Sanchez (at 23rd St), 454-5238

www.noevalleymusicseries.com

There are concerts at this beautiful Victorian church almost every Saturday night. The acoustics are terrific and the programming is truly diverse and innovative. They book both famous and lesser-known performers playing all kinds of music from classical to klezmer to kora (African harp). Tickets go on sale three weeks in advance and most shows start at 8:15. (Noe Valley)

Community Music Center - 544 Capp St (at 20th), 647-6015

www.sfcmc.org/site

This center often sponsors free classical and jazz performances. If you're inclined to tinkle on the ivories yourself, you can use their practice room pianos for just $1 an hour! Stop by for a schedule of events. Daytime and evening performances are often free. Open: mon-sat 9-5. (Mission)

Mezzanine - 444 Jesse St (btwn 5th & 6th), 625-8880

www.mezzaninesf.com

Though well-known for their club nights and parties, Mezzanine is really a multi-media center. There are regularly changing exhibitions, video and film installations, and fashion shows - as well as live music of every stripe. The space is huge, with a big, open dance floor. Upstairs, there are a couple of chill-out rooms. The cover/ticket price is anywhere from $8 to $20. (Downtown/Financial District)

dance clubs

San Francisco's clubs offer an eclectic variety of theme nights and environments. Check the weeklies (see above) for full schedules. And don't forget to bring your ID (see Practical Shit chapter).

Mighty - 119 Utah St (btwn 15th & Alameda), 762 0151

www.mighty119.com

Newer club. Popular. Bit out of the way. (South of Market)

The End Up - 401 6th St (at Harrison), 263-8540

www.theendup.com

Over 30 years old. Lot's of after-hours parties. Fag Fridays. (South of Market)

111 Minna - 111 Minna St (btwn 2nd & Hawthorne), 974-1719

www.111minnagallery.com

Small gallery/bar/nightclub. Check SooperQool every Wednesday. (South of Market)

Pink - 2925 16th St (btwn Mission & South Van Ness), 431 8889

www.pinksf.com

Trendy. (Mission)

The Monkey Club - 2730 21st St (btwn Bryant & York), 647-6546

www.themonkeyclubsf.com

Loungy. Good happy hour all night on Tuesdays. (Mission)

26Mix - 3024 Mission St (at 26th), 826 7378

www.26mix.com

Half-way between club and lounge bar. **Free wifi**. Games room. (Mission)

Performance Art

T he following venues are some of the more innovative, underground, community-oriented places to see performance art in the city. The works often deal with local, political, and social justice issues - so catching a show can be an entertaining way to learn more about the culture and current preoccupations of San Francisco. For schedules, reviews, and comprehensive listings of events in town, check the weeklies (see How to Find Out Who's Playing, Music chapter). It's also a good idea to check *www.laughingsquid.com* for more info about alternative, affordable performances. Also, if you're in town in September, be sure to look out for the Fringe Festival (*www.sffringe.org*) a smorgasbord of experimental and absurdist theater.

Tickets for the more mainstream theaters in town, some of which are also listed here, are sold through the Theater Bay Area Box Office at Union Square (TIX Pavilion, Powell & Geary Street; *www.theatrebayarea.org*). This walk-up box office sells half-price tickets to same day performances. Open: tues-thurs 11-6; fri/sat 11-7; sun 10-3.

performance art venues

ATA (Artists' Television Access) - 992 Valencia St (at 21st), 824-3890

www.atasite.org

This funky little space hosts interesting performances, films, videos and readings in its multi-media facility (see Film chapter). Admission is usually in the $5 range. (Mission)

BRAVA Theater - 2781 24th St (at York), 641-7657

www.brava.org

The BRAVA theater is one of the only in the country to specialize in producing new works by women of color and lesbian playwrights. They have a large theater in which the performances are staged. (Mission)

CELLspace - 2050 Bryant St (at 18th), 648-7562

www.cellspace.org

The work of CELLspace - "an incubator for cultural and community events" - epitomizes the DIY ethic that once flourished in the Mission. Visual and performance art, dance, live bands and DJs are showcased in this communal work space. Open: daily 10-10. (Mission)

Center for the Arts at Yerba Buena - 701 Mission St (btwn 3rd & 4th), 978-2787

www.yerbabuenaarts.org

This art complex consists of two buildings that house several galleries, a screening room, a theater and a garden with an outdoor stage. Diverse shows and performances are presented here as well as interesting films. Gallery admission is $6 ($3 with student ID), and free all day on the first Tuesday of the month. Open: tues/wed, fri-sun 11-5; thurs 12-8. (South of Market)

Climate Theater - 285 9th St (at Folsom), 407-9223

www.climatetheater.com

Climate is small, non-profit organization, yet they present high-quality professional theater productions. They also host regular comedy improv nights and drop-in workshops. Admission is $5 to $10. (South of Market)

counterPULSE - 1310 Mission St (btwn 9th & 10th), 626-2060

www.counterpulse.org

This cool community center supports low-income and emerging artists in their creation of political works of all sorts, which are then presented in the center. (South of Market)

The Dark Room - 2263 Mission St (btwn 18th & 19th), 401-7987

www.darkroomsf.com

The fun performances presented here include, comic plays, stand-up comedy, and the ever popular Bad Movie Night (Sundays at 8:00; $5 - includes free popcorn). The shows feature high quality local talent at affordable prices - free to $15. (Mission)

Femina Potens - 465 South Van Ness (at 16th), 217-9340

www.feminapotens.com

Femina Potens means powerful female in Latin, and that's what these performances are all about. Women and transgendered individuals are encouraged to express themselves artistically in the performances and art produced by this small group of activists. They draw a young, hip, largely queer crowd. Gallery, shop and library open: thurs-sun 12-6. (Mission)

Intersection for the Arts - 446 Valencia St (at 15th), 626-2787

www.theintersection.org

San Francisco's oldest alternative art space presents experimental plays, a literary series, jazz performances and more. Gallery open: wed-sat 12-5. (Mission)

The Lab - 2948 16th St (at Capp), 864-8855

www.thelab.org

Fringe performance and experimental art are the focus of the work presented here. They've hosted some very impressive exhibits in their gallery. Gallery open: wed-sat 1-6. (Mission)

Theater Rhinoceros - 2926 16th St (at South Van Ness), 861-5079

www.therhino.org

"The world's oldest continuously producing professional queer theater" consists of two small halls in which gay-and-lesbian themed performances are staged. (Mission)

folks to look out for

Extra Action Marching Band

www.extra-action.com

They may be called a marching band, but more often than not they're dancing, skipping, staggering, gyrating and crawling. An Extra Action performance is all-out revelry, with a sexy,

gyrating flag team, and a drunken horn and percussion section blasting out deeply infectious music. They've toured Europe and collaborated with David Byrne, but no matter how popular they become, they'll always be San Francisco's own.

Survival Research Labs (SRL)

www.srl.org

This underground, multi-media group (under the creative direction of Mark Pauline), combines artistic esthetics with scientific knowledge to come up with some seriously crazy-ass, brilliant performances. Advanced robots and machines are combined with complicated pyrotechnics: a rocket engine that shoots flames about 15 feet is just one example. Needless to say, the fire department isn't crazy about these guys, so they don't often perform in town. They have, however, expanded their shows to international venues. Visiting their website is the best way to see what they're all about. (Potrero Hill)

The Cacophony Society

www.zpub.com/caco

If a herd of clowns should board the bus you're on, or an "Iditarod Race" with humans dressed as dogs runs by you in the street, you may be experiencing a Cacophony Society event. They're a group of modern Merry Pranksters that enjoy shaking up conventional thinking and dull living. Membership in the society is open to creative spirits everywhere. In fact, as their motto goes, "you may already be a member".

Wise Fool Puppet Intervention

www.zeitgeist.net/wfca/wisefool.htm

This community-minded group of folk artists work in the "European tradition". They perform political street theater with the help of giant puppets, fire, sculpture, music, and stilt walking; and they always encourage audience participation at their performances. Watch for their beautiful puppets at street demonstrations.

Killing My Lobster

www.killingmylobster.com

This performance troupe specializes in sketch comedy. They present their shows at a variety of locations around the city, and they also produce the annual **Hi/Lo Film Festival** (see Film chapter). Call 558-7721 for info on their upcoming gigs.

Billboard Liberation Front

www.billboardliberation.com

This active group of rabble rousers has been culture jamming since the late 1970s. They alter billboards to relay messages about the absurdity of the corporate-controlled media. Keep an eye out for their work.

Sex

San Francisco is, without a doubt, a kinky town. It also leads the US, and perhaps the world, in progressive sexual politics. The Castro district, in particular, has long been an important center of activity for gay rights.

There are an amazing number of sex shops in town and they cater to a wide variety of tastes. Many serve the S/M and B&D scenes with a wide range of leather and bondage gear (see Stormy Leather and Mr. S in the South of Market chapter), but most shops also stock sexy goods of a more mainstream variety.

For free, anonymous, accurate information and referrals about sex and sexuality, call the **Sex Info Line** at 989-7374 or visit their home page: *www.sfsi.org.*

Good Vibrations
1210 Valencia St (btwn 22nd & 23rd), 974-8980; 1620 Polk St (at Sacramento), 345-0400

www.goodvibes.com

Good vibrations is the hottest worker-owned co-op in town. They've been supplying women and their lovers with sexy products since the '70s. They sell all types of sex toys for both women and men: cool metal and glass dildos, vibrators in every imaginable shape and size, erotic books and DVDs, and their own in-house line of specialty products. Check out their collection of discrete vibrators including several that are remote controlled, and one that's disguised as a rubber duckie! Both branches are comfortable places to shop or just browse. Open sun-thurs 11-7; fri/sat 11-8. (Mission, Pacific Heights)

Auto-Erotica - 4077 18th Street (btwn Castro & Hartford), 861-5787

Aimed primarily at men who know that you can't love anyone else until you know how to love yourself, this store stocks handy items, like pumps, impressively large dildos, and butt plugs. They also carry a wide variety of condoms and lubes. And if you're really on a budget, they sell used porn. Open: mon-thurs 11-10; fri/sat 11-11; sun 12-8. (Castro)

The Magazine - 920 Larkin Street (btwn Geary & Post), 441-7737

This shop, a clean, well-lighted place for porn (both gay and straight) carries a full range of vintage and contemporary magazines. In the front you'll find old *Life* magazines, *Saturday Evening Post*'s and that sort of stuff, but head for the back, and you'll find a lot of porn, including some really entertaining old stuff. It's a fun place to browse. Open: mon-sat 12-7. (Tenderloin)

sex

Bondage A Go Go - Glas Kat Supperclub, 520 4th St (at Bryant)

www.bondage-a-go-go.com

For the uninitiated, Bondage A Go Go can be an ideal introduction to the fetish world. Every Wednesday night DJs spin industrial, electro, glam and rock to a dancing, goth-loving crowd. There are also kinky performances and events by the likes of Two Knotty Boys and the Suicide Girls. Fetish wear is strongly encouraged, of course, and at the very least you should definitely not wear jeans or street clothes. Unlike many fetish parties, the cover charge is fairly low. Open: wed 9:30-2:30. (South of Market)

Folsom Street Fair - btwn 7th & 12th

www.folsomstreetfair.com

Once a year, on the last Sunday of September, over 300,000 leather fans pour onto Folsom Street for an S/M extravaganza. It's an event where you can let it all hang out and believe me, people do, with an amazing display of whips, chains, leather and chaps. It's a great celebration of one of the kinky sides of San Francisco. If you've been very naughty, pay a visit to the spanking booth. The proceeds from that, and the rest of the fair, go to charity. (South of Market)

Lusty Lady - 1033 Kearny Street (at Broadway), 391-3991

www.lustyladysf.com

This is the coolest peep show in the country - and maybe even the world. It's owned and operated by the people who work there, guaranteeing an exploitation-free environment. Wow! What you get as a client is your own little coin-operated window in a booth that lets you peep at a stage where 4 or 5 naked dancers are doing their thing. It costs about $1 a minute. They also have private booths with hardcore videos. If you've ever had the urge to peep, this is the perfect place to satisfy that curiosity. Open: 24/7. Live shows: daily 11am-3am. (North Beach)

Phone Numbers

Emergency (police, ambulance, fire): 911

Emergency Health Care (General Hospital, 1001 Potrero Ave, Mission): 206-8000

Police (non-emergency): 553-0123

Drug Crisis Line (24 hours): 781-2224

Mental Health Crisis Line (24 hours): 206-8125

Suicide Prevention (24 hours): 1-800-784-2433

Rape Treatment Center (24 hours): 821-3222

Women Against Rape (24 hour crisis counseling): 647-7273

Youth Crisis Hotline (24 hours): 1-800-448-4663

Health Clinic (Haight Ashbury Free Clinic; 558 Clayton St, at Haight; *www.hafci.org*; low-cost medical services & detox programs; walk-in clinic: mon, tues 4:45pm, tues, wed 8:45am): 487-5632

Traditional Chinese Health Care Clinic (Quan Yin Healing Arts Center; 1,748 Market St, at Valencia; *www.quanyinhealingarts.com*; call for appt): 861-4964

Women's Health Clinic (Lyon-Martin Women's Health Service; 1748 Market Street, suite 201; *www.lyon-martin.org*; general medical and gynecological care; open: mon, tues, fri 9-5, wed 11-7): 565-7667

Birth Control/Abortion Clinic (Planned Parenthood Golden Gate; 815 Eddy; *www.ppgg.org*; drop-in hours: mon, tues, thurs, fri 9-3; wed 11-5:30): 1-800-967-7526

Sex Information (free, anonymous, accurate information and referrals about sex and sexuality; *www.sfsi.org*; phone consultations: mon-thur 3-9; fri 3-7; sat 2-6): 989-7374

Emergency Dental Clinic (University of the Pacific Dental School; 2155 Webster, at Sacramento; walk-in clinic: mon-fri 8:30 & 12:30): 926-6501

Travelers' Vaccination Clinic (101 Grove St, at Polk, Room 102; walk-in clinic: mon, wed, fri 9-4; tues 9-3): 554-2625

Legal Assistance (Bay Area Legal Aid): 982-1300

general info lines

Directory Assistance (for local and long distance phone numbers): 411

MUNI info (mon-fri 6am-8pm, sat/sun 8-6; *www.sfmuni.com*): 673-6864

BART info (mon-fri 4:30am-11pm, sat/sun 6am-11pm; *www.bart.gov*): 989-2278

Greyhound Bus (*www.greyhound.com*): 1-800-231-2222

San Francisco International Airport (24 hours; www.sfoairport.com): 1-650-761-0800

Oakland International Airport (24 hours; www.flyoakland.com): 1-510-563-3300

American Express Travel Service (455 Market St btwn 1st & Beale; open mon-fri 9-5:30; sat 10-2): 536-2600

Lost Mastercard Credit Cards (24 hours): 1-800-307-7309

Lost Visa Credit Cards (24 hours): 1-800-847-2911

embassies & consulates

Australia: 536-1970

Brazil: 981-8170

Canada: 834-3180

Denmark: 391-0100

Finland: 772-6649

France: 397-4330

Germany: 775-1061

Great Britain: 617-1300

Greece: 775-2102

Guatemala: 788-5651

Ireland: 392-4214

Israel: 844-7500

Italy: 931-4924

Japan: 777-3533

Mexico: 392-5554

Netherlands: 981-6454

New Zealand: 399-1255

Norway: 986-0766

Portugal: 346-3400

Spain: 922-2995

Sweden: 788-2631

Switzerland: 788-2272

Amsterdam - *the San Francisco of Europe*

GET LOST!

the cool guide to *Amsterdam*

10th edition | Joe Pauker

the cool guide - buy it... and *GET LOST!*

Index

index